ArtBook
Titian

DORLING KINDERSLEY

London • New York • Sydney • Moscow

Visit us on the World Wide Web at http://www.dk.com

Contents

How to use
this book

This series presents both
the life and works of each
artist within the cultural,
social, and political context
of their time. To make the
books easy to consult, they
are divided into three areas
which are identifiable by
side bands of different
colors: yellow for the
pages devoted to the life
and works of the artist, light
blue for the historical and
cultural background,
and pink for the analysis
of major works. Each spread
focuses on a specific theme,
with an introductory text
and several annotated
illustrations. The index
section is also illustrated
and gives background
information on key
figures and the location
of the artist's works.

■ p. 2: Titian, *Self-
portrait*, 1562, Staatliche
Museen, Berlin.

1490-1510

1511-1518

1540-1551

1551-1560

1490-1510

Titian, *The Concert*, c.1510, Galleria Palatina, Florence

The first steps of an ambitious young man

A boy from
the mountains

Titian was born in Pieve di Cadore – a small town in the Dolomites, surrounded by ancient forests – on the route towards the Alpine passes. The second child of Gregorio Vecellio, he descended from an austere family of lawyers, administrators, and notaries, none of whom had ever undertaken painting. As a result of this background Titian inherited a careful attitude towards money management and a desire for a secluded, humble life that remained with him even after he had become enormously wealthy. In an attempt to appear more authoritative, Titian pretended to be older than he was. Although his date of birth is not known, the most reliable theory locates it between 1488 and 1490. When Titian was nine, he and his older brother Francesco moved to Venice, where their uncle Antonio was working as a civil servant. Their uncle discovered and encouraged the artistic talents of the two boys, and introduced

them to the mosaic workshop of the Zuccato brothers. Before long, Francesco showed more interest in business and military life. Titian, on the other hand, soon became proficient in the art of the mosaic, and went on to work in Giovanni Bellini's studio, one of the most prestigious in Venice.

■ Titian, *St John the Baptist*, detail, 1540, Gallerie dell'Accademia, Venice. The landscape of northern Veneto is represented in the background of Titian's paintings in the form of woods, brooks, and expansive skies.

■ The statue of Titian in the square of Pieve di Cadore is close to the painter's childhood home. A nearby building contains a painting of the Virgin Mary that is fancifully attributed to the child Titian.

■ Titian, *Presentation of the Virgin in the Temple*, detail, 1534–38, Gallerie dell'Accademia, Venice. The mountains in the background of this work, darkened by huge clouds, were probably inspired by the outline of the Marmarole, the mountain range overlooking Pieve di Cadore. This is one of the few landscapes painted by Titian, and it portrays the typical weather and atmosphere of the Dolomites.

■ The Cadore forests were of paramount importance for Venice since they supplied the timber used by the Arsenal for ships and other nautical equipment. One of the woods near Pieve was explicitly called "the oar wood".

Titian in Pieve

Throughout his whole life, Titian maintained a rapport with his native town by keeping a house in Cadore and a financial interest in local mills and the timber trade. He did not produce many works here, but there are many paintings by his followers. At the start of the 19th century, the frescoes executed from Titian's drawings in the parish church of Pieve were destroyed. In the same church, a *Virgin and Saints* by Titian is still kept. In this work, the painter, at the time an old man, inserted a self-portrait.

TIZIANO

IL CADORE

9

The golden years of Venice

In about 1500, when Titian moved to Venice, the "Republic of St Mark" was at the height of its glory. Its commercial empire extended to the middle-eastern Mediterranean, as far as Cyprus; magnificent buildings were being erected; and a pictorial school with a well-defined character began to develop. Because of the damaging effects of humidity and sea water, frescoes were supplanted by grandiose narrative paintings carried out by artists like Vittore Carpaccio and Gentile Bellini, Titian's master. Venice's official painter was Giovanni Bellini, Gentile's brother, who became one of the leaders of the new school thanks to his skilful handling of light and color. Other important artists of this time were the Vivarini family and two painters from small towns around Venice: Cima da Conegliano and the promising Giorgione da Castelfranco.

■ Giorgione,
The Tempest,
detail, c.1505, Gallerie
dell'Accademia, Venice.
This mysterious and
fascinating painting
dates from the time
of the Renaissance
in the Veneto.

■ Giovanni Bellini,
*Portrait of Doge
Leonardo Loredan,*
c.1502, National Gallery,
London. After Agostino
Barbarigo's disgraceful
rule, Loredan, a sensible
man, governed Venice
through a serene and
prosperous time.

■ Gentile and Giovanni Bellini, *Preaching of St Mark in Alexandria*, 1504–07, Pinacoteca di Brera, Milan. This magnificent urban landscape is reminiscent of Piazza San Marco and the Basilica. Gentile Bellini started this painting, but it was completed, upon his death in 1507, by his brother. After Gentile had died, Titian started to work in Giovanni's studio, the most important in Venice.

■ To travellers, and in contemporary representations, Venice appeared like "the most triumphant city in the world". Its buildings had an exotic, almost oriental charm.

■ Vittore Carpaccio, *The Miracle of the Relic of the True Cross*, 1500, Gallerie dell'Accademia, Venice. The story of this miracle is just an excuse for a famous view of the Grand Canal, thronged with boats and crossed by the ancient Rialto Bridge, still made of wood.

Bellini to Giorgione

■ Titian, *Portrait of a Man* (*Giovanni Bellini?*), c.1510, Statens Museum for Kunst, Copenhagen.

During the first decade of the 16th century, Titian went through a series of unusually rich experiences, which, combined with his aggressive temperament, contributed to the development of the exceptional expressive energy that characterizes even his early works. The teachings of his masters (from the Zuccato brothers to Gentile and then Giovanni Bellini) were reinforced by what was happening in the city. These events included the arrival of Leonardo da Vinci in 1500, with his discovery of the *moti dell'anima*, the study of turbulent emotions; the second stay of Albrecht Dürer (1504), who opened international horizons in his *Feast of the Rose Garlands*, painted for the German community in Venice and today kept in Prague; and the melancholic influence brought to Venetian painting by Giorgione. Titian also expanded his cultural horizons: although his education was not strictly humanistic (he found it hard to learn Latin, and in his early letters expressed himself in the local dialect), it enabled him to offer new readings of difficult iconographic themes, such as the enigmatic *Justice* fresco (1508) on the Fondaco dei Tedeschi. This work, carried out in conjunction with Giorgione, marked the end of Titian's apprenticeship.

■ Giovanni Bellini, *Enthroned Madonna with Saints Peter, Catherine of Alexandria, Jerome, and Lucy*, detail, 1505, San Zaccaria, Venice. Thanks to the atmosphere created by a warm golden light, Giovanni Bellini drastically changed the style of altar painting in Venice.

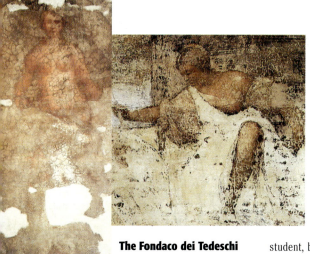

The Fondaco dei Tedeschi

Along with the Rialto Bridge, the decoration of the two fronts of the German commmercial delegation building was one of the main artistic ventures in Venice in the early 1500s. The work was entrusted to Giorgione, who chose Titian, then eighteen years old, not as his student, but as his collaborator. The few fragments left of the frescoes are kept in Venice, in the Galleria Franchetti alla Ca' d'Oro. The two female figures above reveal the difference between the artists. Giorgione's *Female Nude* is full of quiet grace, while Titian's lively *Justice* conquers the space around her with the same energy with which the painter was establishing himself on the Venetian art scene.

■ Giorgione, *Sleeping Venus*, 1510, Gemäldegalerie, Dresden. This pensive image draws a parallel between the harmony of the female form and the sweetness of nature. On Giorgione's death in 1510, Titian completed this painting with the insertion of the red and white drapes.

■ Titian, *The Birth of Adonis; The Forest of Polidorus*, c.1506, Museo Civico degli Eremitani, Padua. These two mythological scenes are among Titian's earliest works. Painted on long, thin wooden panels, they were both intended as decorative elements for a piece of furniture.

MASTERPIECES

St Peter's Altarpiece

Kept in the Musées Royaux in Antwerp, this altarpiece, dating from between 1506 and 1509, celebrates Jacopo Pesaro's naval victory against the Turks in 1502. Along with Pope Alexander VI, the victor kneels in front of his patron, St Peter.

■ The pedestal of St Peter's seat is decorated with a bas-relief of a scene of sacrifice. The positioning was meant to emphasize the supremacy of Christian faith over paganism and to reiterate the meaning of the whole work, that is the celebration of a victory over the "infidels".

■ The figure of St Peter, sitting on a throne and in the act of blessing, is directly inspired by the style of Giovanni Bellini. Indeed, many art critics believe it was painted by Bellini himself.

■ The portrait of Pope Alexander VI, the notorious Rodrigo Borgia, is reminiscent of Gentile Bellini's technique, especially in the well-defined line delineating the profile. Titian did not portray him from life, but based his figure on an etching or drawing circulating at the time. This could account for the less vibrant nature of the portrait in comparison with the other characters.

■ The chiaroscuro that bathes Jacopo Pesaro's features revealing his inner intensity is a homage to Giorgione. The bishop holds the banner bearing the family coat of arms, while the ships in the background are a reminder of the victory.

■ Jacopo Pesaro and his banner appear in another painting by Titian, the grandiose *Pesaro Altarpiece* in the Basilica dei Frari in Venice, one of the painter's major works (pp. 56–57).

Europe against Venice: the League of Cambrai

Venice's political and economic power was weakened in 1509, when the great European powers created an alliance against the city. A few years earlier, the French and Spanish armies had conquered the duchy of Milan, and formed a bridge-head on the kingdom of Naples. The Holy League, created

Der groß Venedigisch krieg

■ Armed with crossbows, the Lansquenets were formidable opponents for the Venetian army.

by Emperor Maximilian of Austria, and ratified by the Agreement of Cambrai, attacked the Venetian army at Agnadello, inflicting a terrible defeat upon Commander Bartolomeo d'Alviano. Soon Verona, Vicenza, and Padua fell to the allies: Titian's grandfather was the protagonist of a heroic resistance in Cadore. When the allies set fire to Mestre, the Venetians braced themselves for a siege on the lagoon. The farmers' rebellion and political considerations changed the outcome of the war: the imperial army retreated, leaving behind devastation and pestilence. The Treaty of Noyon (1516), gave Venice absolute power over the occupied territories.

■ Titian, *Horseman Falling*, c.1537, Ashmolean Museum, Oxford. This is a preparatory sketch for the painting of a battle, possibly the resistance in Cadore. Completed by Titian in 1537, the painting was destroyed in the fire of the Doges' Palace in 1577.

■ In *The Great War of Venice*, an illustration from a book on the military exploits of Emperor Maximilian (Albertina, Vienna), painter Albrecht Altdorfer shows the events as seen by the victors. The lion of St Mark dives into the lagoon, frightened by the approaching allied army.

■ Titian, *The Jealous Husband*, 1511–12, Scuola del Santo, Padua. This is one of three important frescoes painted by Titian to celebrate the miracles of St Anthony in Padua. The gesture and the attire of the man stabbing his wife are reminders of the Lansquenets and their violent actions in the Venetian territories during the war of 1509.

■ Almost a century after the war, Alessandro Varotari, called Padovanino, depicted the events as seen by the defeated, who were by then vindicated. In his *Allegory of the War Against the Holy League* (Palazzo Ducale, Venice) Doge Loredan is crowned with a laurel wreath, while the aggressive lion and the personification of Venice with the raised sword drive back the enemy.

"Fête Champêtre"

Housed in the Musée du Louvre, Paris, this painting dates from about 1510. Its authorship is still under debate: today most art historians believe it to be the work of Titian, while some attribute it to Giorgione.

■ The glass carafe shining with reflected light is a delicate detail of symbolic value that required superior technical skills. This recurring element in Titian's early work can be seen as an inspiration for Caravaggio's still lifes.

■ In the background, the shepherd and his flock bring a sense of humanity and reality to the scene. His rural presence renders the work more than a contemplative exercise; it is a realistic portrait of the landscape and life in the Veneto.

■ The lute and the flute are the instruments of this "concert", which is really a duet. There have been many critical readings on their significance, and they are often interpreted as erotic symbols in the style of Giorgione. The sensual atmosphere of the scene is countered by the distant landscape and the characters' serene gestures and expressions.

■ Titian's painting was greatly admired by the Impressionists, who appreciated the sense of realism, the application of the colors, and the use of light. Indeed, this work inspired Manet's *Déjeuner sur l'herbe* (Musée d'Orsay, Paris).

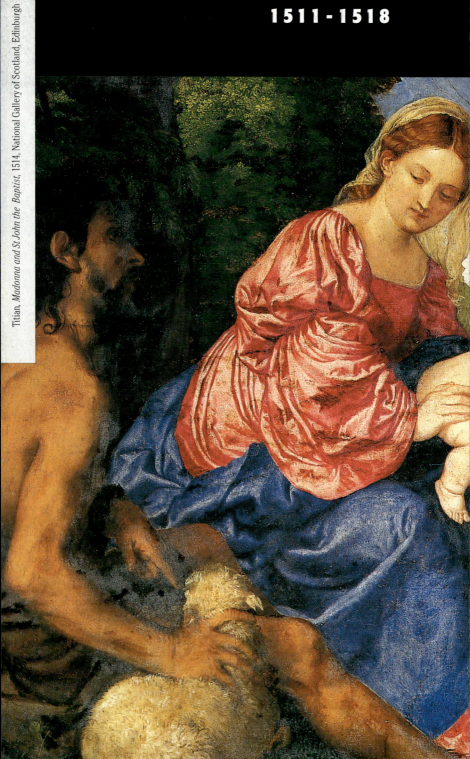

Titian, *Madonna and St John the Baptist*, 1514, National Gallery of Scotland, Edinburgh

LIFE AND WORKS

Early triumphs

■ Titian, *Madonna and Child, and Saints Ulfo and Bridget*, detail, c.1515, Museo del Prado, Madrid. St Ulfo's face is a self-portrait of the 25-year-old artist. Titian's face can be seen in several works of his youth and early maturity. Only later in life, when he was about 70 years old, did he paint two independent self-portraits.

Following the death of Giorgione in the plague of 1510, Titian acquired a position of prestige within the new generation of Venetian artists. The frescoes he painted in Padua proved enormously successful, overwhelming even Sebastiano del Piombo, who left Venice in 1511 to settle in Rome on a permanent basis. Titian's well-organized studio and the support of influential thinkers such as Andrea Navagero and Pietro Bembo enabled him, in 1513, to obtain his first State assignment – creating a battle painting in the Doges' Palace. He was 25 years old. For this work, which was destroyed in 1577, Titian demanded and obtained several important privileges that enabled him to lay the foundations to his extraordinary wealth, but also attracted the jealousy of the ageing Giovanni Bellini, who had been Venice's official painter for years. Titian's role as an artist was consolidated in 1516: *The Assumption* was commissioned for the high altar in the Basilica dei Frari, he established the first contacts with the Duke of Ferrara Alfonso d'Este, and, after Giovanni Bellini's death on November 29, the prestigious role of official painter became his.

■ Titian, *The Three Ages of Man*, c.1512, National Gallery of Scotland, Edinburgh. This symbolic theme is set within a evocative landscape that is reminiscent of the style of Giorgione.

■ Titian, *The Miracle of the Speaking Babe*, 1511, Scuola del Santo, Padua. This is one of three frescoes dedicated to St Anthony and painted in Padua, where Titian had gone to avoid the plague. It was Titian's first prestigious and independent commission. Although they are the artist's only surviving frescoes, they demonstrate his complete familiarity with the technique.

■ Titian, *St Mark Enthroned, with Four Saints*, 1511, Santa Maria della Salute, Venice. This small votive altarpiece was carried out to mark the end of the plague in which Giorgione had died. Within a strikingly chromatic context, Titian let the clouds shade the face of the patron saint of Venice, a rather nonconformist move for the times. On the left are the medical saints Cosmas and Damian, on the right, the thaumaturgical saints Sebastian and Roch; the latter, with long hair and a dark beard, is another self-portrait.

23

1511-1518

Sacred and Profane Love

The name by which this work (1514–15, Galleria Borghese, Rome) is commonly known was applied at the end of the 17th century. The meaning of the grandiose composition remains both controversial and unclear.

■ The rabbits, a symbol of fertility, underline the original purpose of this work, a wedding gift for a gentleman called Niccolò Aurelio.

■ The classic bas-relief decorating the fountain brings a note of unpredictable brutality to the calm and serenity of the scene.

■ This delightful Cupid, portrayed as he stirs the crystal-clear water in the fountain, could be the key to the interpretation of this painting. The central figure of Love is the link between these two beautiful women. According to the most credited theory, the female characters are twin sisters embodying the two different ideals of beauty praised by Neo-Platonic humanism.

■ The open landscape on the right-hand side is reminiscent of Giorgione's work. On the whole, however, this painting represents Titian's definite parting from the influence of this artist. The richness of the colors and the striking vitality of the figures are hallmarks of Titian's individual style.

Venice: the government of a State

Renaissance Venice was the supreme example of political and administrative organization. The Doges' Palace dominated the whole city and was the physical and symbolic center of power: within the Palace were the main offices, the meeting rooms, the private apartments of the Head of State, and the Piombi prisons. The main aristocratic families constituted the largest representative body, the Great Council. It was the Great Council that was responsible for electing officials and magistrates of the Republic, the Quarantia (the supreme court of criminal and civil law), and the awesomely powerful Council of Ten. At the top of this pyramid of power was the doge, elected to a life-long position through a convoluted system. Although virtually devoid of effective power, the doge embodied and influenced the life of the State. This was particularly true when a charismatic person was elected to the role.

■ The Giants' Staircase, named after Sansovino's marble statues, is the main entrance to the upper floors of the Doges' Palace. The Palace was the seat of civil power in Venice.

■ Vittore Carpaccio, *The Lion of St Mark*, 1514, Palazzo Ducale, Venice. The winged lion, symbol of the patron saint of Venice, rests his paws both in the sea and on the land to underline the dual supremacy of the city.

■ The doge's cap was also known as "camàuro". It was covered in precious stones and was one of the most eloquent symbols of power.

■ This 15th-century French miniature shows the doge surrounded by the members of the Council of Ten. Below them, the clerks duly and immediately translate any decision into an official edict.

■ Lorenzo Lotto, *Portrait of Andrea Odoni*, Royal Collections, Hampton Court. Odoni was an art dealer, a collector of antiques and paintings, and a refined intellectual. He embodied the ideal of the Venetian gentleman: wealthy, cultured, and fond of the arts. Lorenzo Lotto's painting, lit by a warm, soft glow, is a masterpiece of portraiture.

Public and private commissions

At the beginning of his career, Titian divided his time between works destined for public places, which were usually executed extremely slowly, and those for private collectors. His early efforts in portraiture proved to be enormously successful, as did his paintings of female figures. Indeed, Titian's sensual portraits became prized trophies among aristocrats and wealthy merchants alike. From a young age, Titian managed to give his profession a modern, entrepreneurial direction, establishing his workshop as a commercial asset. Along with Raphael, Titian was the first artist to consider his signature as an added value to the painting, and to organize the work in his studio according to three degrees of increasing responsibility: apprentice, collaborator, and assistant.

■ Titian, *Flora*, 1516, Galleria degli Uffizi, Florence. This is a typical example of Titian's paintings of sensuous female figures. This genre was a celebration of the ideal of Venetian beauty, representing voluptuous young ladies with blonde hair, innocent eyes, and rosy complexions.

■ Titian, *Salome*, 1516, Galleria Doria Pamphili, Rome. Titian's female figures were drawn from sources as varied as classical mythology and the Gospels. The severed head of St John the Baptist is a self-portrait, and the main colors, red and green, were obtained by using superior dyes.

■ Titian, *Portrait of a Man*, c.1510, National Gallery, London. For a while, this unknown gentleman was considered to be the poet Ludovico Ariosto; today, however, most critics seem to believe he could be a member of the Barbarigo family. This striking portrait was praised by Vasari as a masterpiece of precision and vibrant brilliance. It is an excellent example of Titian's talent in portraiture, the genre that was to bring him international fame.

The case of the executioner

Throughout the 1500s, this painting was without doubt the most famous and invoked sacred image in Venice. Many years of intense devotion seem to have left their mark, and today the canvas appears almost worn. Although there are doubts as to the authorship of this Leonardesque painting of Christ being dragged to Calvary, it is quite possible that it was planned by Giorgione and completed by Titian. Art historian Giorgio Vasari gave no indication of the artist, but he wrote: "This painting raised a lot of money in alms, certainly more than Giorgione and the extremely rich Titian ever earned in their whole lives."

■ Titian or Giorgione, *Christ Carrying the Cross with an Executioner*, c.1510, Scuola di San Rocco, Venice.

BACKGROUND

Priors, Scuole, nobles, and merchants: Titian's clients

Titian's patrons came from the wealthy and aristocratic classes of Venice. At the beginning of the 16th century, about 150,000 people lived in the city and, although governed by an aristocratic oligarchy, Venice was proud of its image of democracy and freedom. Beside its administrative structure, the city could count on corporate welfare bodies such as its *Scuole* (literally "Schools"). There were about sixty of these unions of local or foreign workers, and the five main ones had several thousand associates. The buildings housing the Scuole were decorated with grandiose narrative paintings portraying the lives of the patron saints. Works commissioned by religious patrons were also important: from the smallest oratory to the Basilica San Marco, churches in Venice were gradually filled with works of art. Of particular interest were the requests of two conventual churches, San Zanipolo and the Basilica dei Frari: the prior of the latter, Father Germano, commissioned *The Assumption*. Other important clients were wealthy foreign merchants, especially Germans, who were avid art collectors.

■ This painting by Albrecht Dürer portrays Jacob Fugger, a banker and merchant from Augsburg. He was one of the wealthiest men in Europe, and had vital commercial links with Venice.

■ This is the famous seal of the Aldine Press founded by the Italian scholar Aldus Manutius at the beginning of the 16th century. Manutius printed small, affordable editions of Greek and Latin classics.

■ In this detail from *The Banker and his Wife* by the Flemish artist Quentin Massys, illuminated books, golden coins, and works of art can be seen on the table.

■ Titian, *Portrait of Cardinal Pietro Bembo*, 1540, National Gallery, Washington.

■ Titian, *Flyer for Alms for the Scuola di San Rocco*, 1523. This unusual flyer was intended to encourage alms-giving in honor of St Roch and finance the construction of a new site for the Scuola. On the top of the flyer is a reproduction of the famous painting *Christ Carrying the Cross with an Executioner* (see p. 29).

Titian and Pietro Bembo

Cardinal Pietro Bembo was Titian's first important admirer, and this portrait is a sign of the painter's gratitude. Not only was Bembo one of the main poets and linguists of the Renaissance, he was also secretary to Pope Leo X, the official historian of Venice, and an important cultural link between the Republic of Venice and Rome. During the first half of the 16th century, Bembo was an intellectual figure of remarkable influence: among other things, he promoted a profound reformation of Italian as a literary language in his *Prose della volgar lingua*. His work *Dialoghi degli Asolani*, written at the court of Queen Caterina Cornaro, was a source of poetic inspiration for Giorgione. Pietro Bembo started to support Titian as early as 1513, and tried many times and in many ways, including official invitations and financial rewards, to persuade the painter to move to Rome. He only succeeded 30 years later, in 1545.

■ Vittore Carpaccio, *The Disputation of St Stephen*, detail, 1514, Pinacoteca di Brera, Milan. In this painting, which was part of a cycle executed by Carpaccio for the Scuola dei Lanieri (wool manufacturers), the councillors of the Scuola are portrayed wearing their official red and black uniforms.

1511-1518

Assumption of the Virgin

Commissioned in 1516 and first shown on March 20, 1518, this painting still adorns the high altar of the Basilica dei Frari in Venice. Almost 7 metres (21 feet) high, it is Titian's largest work.

■ The figures on the ground are the apostles. It seems that Titian used ordinary street people, including some fishermen, as his models. Although Leonardo had already done so 20 years earlier for his *Last Supper*, Titian's choice provoked doubts as to the suitability of such a "scandalous" work of art for a church.

■ To avoid a static sense of symmetry, God is placed diagonally to the rest of the picture. Indeed, His figure projecting upon the golden heavens greatly contributes to the sense of movement pervading the whole scene.

■ Musical angels are extremely rare in the works of Titian. Indeed, even in this tumult of cherubs lifting the Virgin Mary, only a few carry musical instruments. It is worth mentioning, however, that Titian was such a music lover that he even traded one of his portraits for a portable organ, and used to organize small concerts in his house.

■ A comparison with the serene *Assumption* by Jacopo Palma il Vecchio, completed only a few years earlier (1512, Gallerie dell'Accademia, Venice), helps to explain the revolutionary importance of Titian's work, and its innovative, dramatic energy. Contemporary art critics compared it to "the magnitude and awe of Michelangelo, the pleasantness and beauty of Raphael, and the true colors of nature."

Titian, *The Madonna of the Cherries*, c.1515–18, Kunsthistorisches Museum, Vienna

The joys
of youth

1519-1525

Bacchanals for the d'Este court

Titian's Venetian success was soon followed by fame outside the Republic. The first nobleman to request the artist's services was Alfonso d'Este, the friendly and ambitious Duke of Ferrara. In 1516 he received Titian as a guest at his court for a few months and, in return, the artist started a series of paintings, took care of small jobs, and purchased works of art for the Duke. His most important task, however, was decorating the duke's study room in the castle. Between 1518 and 1523, Titian completed three splendid mythological paintings for this "alabaster room", tragically destroyed in 1598. He also restored *The Feast of the Gods*, a work by Giovanni Bellini that had been sent to Ferrara a few years earlier. Until 1524 Titian travelled on a regular basis to Ferrara, where he was always welcomed with the highest regard.

■ The d'Este Castle in Ferrara. Duke Alfonso d'Este had wanted his study room built here, just above the noisy street market.

■ Giovanni Bellini and Titian, *The Feast of the Gods*, 1514 and 1520, National Gallery, Washington. This serene gathering of the gods on Mount Olympus is one of Giovanni Bellini's last works, and Alfonso d'Este specifically selected it as the model for the bacchanals for his "alabaster room". In order to create some kind of continuity with the new works of the cycle, Titian brought some significant alterations to this painting, adding new vigor and energy to the landscape and sky.

■ Titian, *Bacchanal: The Andrians*, 1518–19, Museo del Prado, Madrid. Titian invested mythological scenes with great force and brilliance, portraying them as a feast of beauty and joy. Also at the Prado is *The Worship of Venus*, the second painting of the cycle created for Alfonso d'Este. Both works were completed in 1519.

■ Titian, *Bacchus and Ariadne*, 1522–23, National Gallery, London. This bacchanal embodies the sensuous spirit typical of the early phase of Titian's mythological painting.

Ferrara and Mantua: the Renaissance courts

BACKGROUND

During the 1500s many European states, such as Spain, Austria, France, and later England, established themselves as the new powers. Although most independent courts were absorbed into the newly created states, a few retained their autonomy, thanks to careful political alliances and a policy of neutrality. In particular, two closely related dukedoms in northern Italy – the Gonzaga in Mantua and the d'Este in Ferrara – reached the height of a cultural and artistic growth that had begun in the 1400s. Literary figures and artists were often seen at these courts. Ferrara welcomed two of Italy's greatest Renaissance poets, Ludovico Ariosto and Torquato Tasso, while inventive architectural and decorative work was undertaken in Mantua, such as the enlargement of the Palazzo Ducale and the building of the Palazzo del Tè by the ingenious Giulio Romano. Titian was in demand with both Alfonso d'Este and his cousin Isabella Gonzaga, for whom he created many paintings. The sad decline of the two cities (swift for Ferrara, slow and agonizing for Mantua) was accompanied by the dispersion of the dukes' renowned artistic collections: their paintings are now scattered throughout the world.

■ Isabella Gonzaga's private apartment, the most intimate and elegant part of the Palazzo Ducale in Mantua, is decorated with charming wood carvings from the early 1500s.

■ The Gallery of Mantua's Palazzo Ducale was created as a showcase for the Gonzaga's artistic and archeological collections.

■ Titian, *Portrait of Laura Dianti*, 1523, Kisters Collection, Kreuzlingen. It is likely that this gaudy lady was Alfonso d'Este's lover. After adopting the false, high-sounding name Eustochio, she became his wife.

■ Titian, *Portrait of Giulio Romano*, 1536–38, Collezioni Comunali, Mantua. Recently purchased at the auction of the collection of Philippino dictator Ferdinand Marcos, this is the only painting completed by Titian during his stay in Mantua to be returned to the city.

■ Titian, *Portrait of Isabella Gonzaga*, 1536, Kunsthistorisches Museum, Vienna.

Isabella Gonzaga

Titian's rapport with Mantua's marchioness, possibly the only "queen" of the Italian Renaissance, lasted for at least 15 years. A widow at a young age, not only did Isabella govern the state through a difficult period, she also found the time to devote herself to the arts. She held a correspondence with the main painters of the 16th century, and in her letters she expressed intelligent, valid opinions. When she commissioned this work, she did not sit for Titian, but instead asked him to "reinvent" one of her portraits from twenty years earlier. Upon seeing the result, she wrote: "I doubt that I was ever the age represented here, as I doubt I was ever this beautiful."

1519-1525

The Gozzi Altarpiece

Signed and dated 1520, this altarpiece was commissioned by a gentleman from Dubrovnik named Alvise Gozzi. It used to adorn the Chiesa di San Francesco in Ancona, but today is kept in the Pinacoteca Civica in the same city.

■ By tracing the direction in which each character is looking, one can see the principles of coherence within this apparently asymmetric piece. Each person gazes at someone else, therefore creating an effective play of crossing glances.

■ The two cherubs balance the upper level of the painting, unifying it with the figures below. They each carry a crown of flowers, but while one offers his to the Virgin Mary, the other looks down curiously upon St Alvise and the donor.

■ The figure of the client yet again confirms Titian's talent in portraiture. Although represented in the traditional pose of supplication, Gozzi's portrait conveys a very tangible sense of physical strength and aggression.

■ In the background is a view of Venice in which one can clearly make out the docks, the Doges' Palace, the bell tower, and the domes of the Basilica San Marco.

The portraits

Throughout his long life, Titian was at the center of a lively critical debate that, for a few years, focused around two main poles: art critics and writers from Tuscany on

one side, and those from the Veneto on the other. In spite of their sometimes irreconcilable opinions, critics from both sides always agreed that Titian's portraiture was nothing short of glorious. Until Titian, nobody had ever seen characters on canvas brought to life with such striking force, their physical portraits supported by what seemed accurate representations of their souls. The artist painted portraits throughout his career, until the last years of his life. He was an extremely expensive artist and, therefore, most of his portraits were dedicated to illustrious figures, whose vigorous expressions, imperious gestures, and

confident attitudes underline their glory. Contemporary writers like Pietro Aretino and Monsignor Giovanni della Casa tried to explain the charm and magic behind these "talking" and "thinking" images. A famous anecdote tells of a portrait of Pope Paul III, executed by Titian during his stay in Rome. The painting had been put on a terrace to dry, and passers-by would respectfully salute it, in the mistaken belief that it was the pope himself looking down from the balcony.

■ Titian, *The Man with the Glove*, c.1523, Musée du Louvre, Paris. It is difficult to ascertain the identity of this young man, but the fact that the painting comes from the Gonzaga collection indicates that he was from Mantua.

■ Titian, *Portrait of Vincenzo Mosti*, c.1520, Galleria Palatina, Florence. Mosti was a dignitary at the d'Este court. Painted by Titian during one of his many happy sojourns in Ferrara, this exquisite portrait displays a delicate use of subtle shades of gray.

■ Titian, *Portrait of a Woman: the Serving Woman*, c.1515, National Gallery, London. In this unusual double-portrait experiment, the lively, portly lady is represented standing by a balcony decorated with a bas-relief of her own profile.

■ Titian, *Man in a Red Cap*, c.1516, Frick Collection, New York. This delicately defined details and atmosphere of veiled melancholy in this work are reminiscent of Giorgione.

■ Titian, *Portrait of a Man*, c.1540, Galleria Palatina, Florence. This painting comes from the Urbino collection of the della Rovere family, and is sometimes called *The Young Englishman*, since several critics believe it to be a portrait of the Duke of Norfolk.

43

The Averoldi Polyptych

Executed between 1520 and 1522 for apostolic delegate Altobello Averoldi, this altarpiece is still in the Chiesa dei Santi Nazaro e Celso, in Brescia. Its original frame, however, has since been replaced.

■ The angel in the upper section inspired many 16th-century painters from Brescia (Savoldo, Moretto, Romanino) and possibly even Caravaggio. In the lower panel, Titian portrayed his client kneeling as well as Saints Nazaro and Celso, to whom the church was dedicated.

■ The resurrected Christ is lifted above the sepulchre by a supernatural wind that beats against His loincloth and banner. His facial features are very similar to those of St Sebastian – this is because they are both hidden self-portraits.

■ Although it contains Titian's signature and the date, the panel with St Sebastian was the first to be painted. In 1520 Alfonso d'Este had demanded it as a forfeit against the missed deadline of the bacchanals for his study room.

■ The twilight glow bathing the landscape at the center of the work gives a reddish tone to the main panel and unifies the polyptych.

1519-1525

Doge Andrea Gritti

Upon the death of the 89-year-old Antonio Grimani in 1523, Andrea Gritti, a man with a controversial past, was elected doge. Soon after his election, this demanding and ambitious character started a vigorous campaign to revamp the image of Venice, which he saw as the "new Rome". The Reformation had weakened the position of Rome as papal city, and most Italian states were experiencing increased difficulties in the face of foreign powers. Gritti used these arguments to suggest Venice as the new, free capital of Italy. In order to support this "candidacy", he initiated a radical renovation of architecture based on the new ideas of classicism, and enrolled Titian as the resident artist, rewarding him by offering both him and his family excellent benefits.

■ The costumes and habits of 16th-century Venetian women were described in *Ancient and modern costumes of the world*, a book written and illustrated by a grandnephew of Titian, Cesare Vecellio, and published in 1590.

■ Titian, *Portrait of Doge Andrea Gritti*, 1540, National Gallery, Washington. Another formidable example of Titian's portraiture, this painting reveals the proud character of Andrea Gritti, the man who was to alter the face of Venice.

■ This map, engraved by Jacopo de' Barbari in 1500, shows large freighters anchored in the Venetian docks.

■ Jacopo Tintoretto, *Votive Picture of Doge Andrea Gritti*, detail, Palazzo Ducale, Venice. Every doge would traditionally request a large votive painting of himself kneeling devoutly in front of the Virgin Mary. Tintoretto's work replaced the original one by Titian, which burnt in the fire of the Doges' Palace in 1577.

■ Titian, *St Christopher*, 1524, Palazzo Ducale, Venice. Gritti was a superstitious man, and requested Titian to fresco his private rooms with the figure of St Christopher, protector against violent death.

Titian, *The Entombment*, 1525, Musée du Louvre, Paris

Titian's family

By the age of 35, Titian was professionally established: not only was he the key artist within Gritti's administration, he was also requested by the courts of both Ferrara and Mantua, his works were in great demand from collectors, and he was becoming extremely rich. In spite of all this, Titian remained in his small workshop in San Samuele, which he managed profitably. He was living with a girl from Feltre, Cecilia Soldano, who bore him two sons, Pomponio and Orazio. Upon the birth of the latter, in 1525, Titian married Cecilia: his witnesses at the wedding were his brother Francesco and the artist Gerolamo Dente, a trusted collaborator in his studio. In 1530, Cecilia, who suffered from poor health, died a few days after giving birth to their daughter Lavinia. Titian never remarried and for the rest of his days played an active part in his children's lives. Indeed, although he was a public figure who could have attracted gossip and slander, there were never any hints of romantic scandal. In 1555 Lavinia married Cornelio Sarcinelli, a gentleman from Serravalle (now Vittorio Veneto). Orazio, Titian's favourite son, stayed with his father until his death, helping in the workshop and with its administration, while Pomponio became a lazy, indolent man, and embraced with little enthusiasm an ecclesiastical career.

■ Giovanni Stradano, *The Artist's Studio*, etching. This lively representation of a 15th-century painter's studio shows the master working at the easel while his helpers and apprentices rush around him, busying themselves with all kinds of tasks.

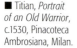

■ Titian, *Portrait of an Old Warrior*, c.1530, Pinacoteca Ambrosiana, Milan.

■ Titian, *Portrait of a Girl*, 1545, Gallerie di Capodimonte, Naples. Traditionally this sweet-looking girl is thought to be Titian's beloved daughter Lavinia, then 15 years old.

Home and studio

From the early stages of Titian's career, his home and studio were one and the same. He applied a strict organizational regime to his workshop, choosing collaborators with extreme care and allowing only a small degree of involvement from his family. Only his brother Francesco, and later his son Orazio, became working members in the studio. One of the first artists to become aware of the importance of public relations, Titian hired prestigious agents like Pietro Aretino, Monsignor Giovanni della Casa, and Ludovico Dolce to promote his workshop internationally.

■ Titian, *Portrait of a Young Girl: Violante*, 1515–18, Kunsthistorisches Museum, Vienna. This is undoubtedly one of the most seductive, penetrating portraits of Titian's early years, and it is named after the small violets on the girl's cleavage. Suggestions as to the identity of the subject include Titian's fiancée Cecilia and Palma il Vecchio's daughter. The mystery has yet to be solved, partly because there are no undisputed portraits of Cecilia in existence.

Portrait of Federico Gonzaga

Painted between 1523 and 1525, during one of
Titian's stays in Mantua, this portrait is today in
the Museo del Prado in Madrid.

■ The son of Isabella Gonzaga, Federico was almost maniacal about his appearance and even identified himself with the traditional iconography of Jove, the ruler of Olympus.

■ The court of Mantua was extremely refined in its tastes and this was reflected in, among other things, its food and costumes. This splendid velvet jacket embroidered with gold is assumed to be similar to the one Federico presented to Titian to encourage him to work in Mantua.

■ This small dog brings a delightful touch of reality to this celebratory portrait. The Gonzagas were renowned for breeding hunting dogs, but this family pet giving a paw to its master is certainly not the type of dog for which they were known.

From Renaissance to Mannerism

Italian art underwent a radical renewal during the 1520s. Perspective, symmetry, and order, the laws of artistic composition in the previous century, suddenly seemed inadequate to express the passions aroused by recent historical events such as Charles V's climb to power, the battles for foreign rule over Italian territories, and the Protestant Reformation. Titian's supremacy in and around Venice gave local art a well-defined direction, but in other regions many new trends followed one another in quick succession. Although these styles introduced a new vision of the world, they were all respectful of the authority of Raphael – who had died prematurely in 1520 – and Michelangelo. The most radical among the new trends was Mannerist art, developed by Pontormo and Rosso Fiorentino in Florence. Its main characteristics were bright colors, accurate linework, intense expressions, unnatural poses, and a disregard for perspective. Mannerism became very successful in central Italy while, in northern regions, interesting alternatives developed. These included the sentimentality of Correggio, the robust naturalism of the Lombards, and the restless psychology of Lorenzo Lotto.

■ Lorenzo Lotto, *The Annunciation*, 1527, Pinacoteca Comunale, Recanati, Italy. In Bergamo, where he lived between 1513 and 1525, Lotto found an oasis of serenity during his otherwise tormented life. Free from outside influences, this careful chronicler of daily reality and emotions offered new readings of traditional artistic themes, as can be seen in this tense and chilling *Annunciation*.

■ Michelangelo, *Tomb of Giuliano de' Medici with Allegories of Night and Day*, Sacrestia Nuova di San Lorenzo, Florence. Though never completed, Michelangelo's work on the funerary chapel for the Medici dukes, is one of his finest architectural-sculptural achievements. The chapel stands as a formidable reminder of the crisis of Renaissance ideals, and as the ultimate example of his monumental art.

■ Correggio, *The Nativity ("La Notte")*, 1522, Gemäldegalerie, Dresden. Painted for a church in Reggio Emilia, this work reveals the all-encompassing humanity of Correggio, which contributed to many key artistic developments.

■ Correggio, *Madonna and St Jerome ("Il Giorno")*, 1523, Galleria Nazionale, Parma. This altarpiece is traditionally considered part of a pair with *The Nativity* (above), and is a typical example of Correggio's originality. Without the excesses of Mannerism, he gave new life to traditional schemes and became the link between Leonardo, whose influence is clearly visible in the Virgin's features, and Baroque art.

■ Raphael, *The Transfiguration*, 1520, Pinacoteca Vaticana, Rome. Painted from a sketch by Michelangelo, and in competition with Sebastiano del Piombo, this, Raphael's most dramatic work, was left unfinished due to his early death. The lower part of the picture, with figures transfixed in eloquent gestures and expressions, was an important stimulus for Mannerism.

MASTERPIECES

The Pesaro Altarpiece

Commissioned by Jacopo Pesaro, bishop of
Paphos, in 1519 for his family altar in the Basilica
dei Frari in Venice, this work was completed
only in 1526.

■ As they play with the cross, the two putti are totally oblivious to what is happening below them. Their presence hints at an indefinite, unlimited space beyond the painting, as do the two gigantic columns behind the characters. The insertion of these majestic features represents a dramatic break from traditional altarpieces, which, during the Renaissance, were usually set within a clearly defined architectural space. The columns are completely out of proportion with the figures and do not seem to have any precise function. They do, however, give the painting an extraordinary sense of height and a monumental feel.

■ The gestures and the directions of the looks are revolutionary: the Virgin and Child are not at the center of the picture, yet they remain the focus of attention. Mary looks towards Jacopo Pesaro, while the infant Jesus gazes upon St Francis. The latter extends his hand towards the other members of the Pesaro family, who are in turn also observed by the other Franciscan friar.

■ All the members of the Pesaro family look towards Jacopo, who is shown kneeling on the opposite side. There is, however, one exception: a young boy with silver-colored clothes, who glances innocently at the viewers, drawing them into the picture.

The Sack of Rome

On May 6, 1527, a group of Swiss Lansquenets, part of Charles V's army, invaded Rome: for two weeks the Eternal City was subject to severe pillaging, which terrorized both the Vatican and the Roman citizens. The consequences of the attack were extensive material damage as well as devastating psychological effects, and it effectively put an end to the golden age of the Renaissance. Pope Clement VII, a prisoner in his own Castel Sant'Angelo, was left to observe the pillaging, unable to put a stop to it: even precious golden ornaments from St Peter's ended up in the looters' hands. Artists and intellectuals fled the city, and this sudden exodus accelerated diffusion throughout Italy of the style of early Mannerism. Venice welcomed two refugees from Rome who were to become Titian's close friends as well as influential figures within the cultural scene – polemist and writer Pietro Aretino and architect Jacopo Sansovino. Conversely, one of the most important artists in the capital, Sebastiano del Piombo, who 20 years earlier had worked with Titian in Giorgione's studio, remained in Rome. His loyalty was rewarded by Clement VII with so many benefits and incentives that he no longer needed to paint for financial gain.

■ Vittore Carpaccio, *The Engaged Couple Being Greeted by the Pope in Rome*, detail, 1497, Gallerie dell' Accademia, Venice. Castel Sant'Angelo in Rome can be seen in the background of this work.

■ In this 15th-century Spanish miniature, kept in the library of the Escorial, Emperor Charles V is surrounded by the heraldry of Augsburg and by the crowned members of his family.

■ Albrecht Altdorfer, *The German Knights*, illustration from *Enterprises of Emperor Maximilian*, Albertina, Vienna. The brightly colored clothes, unusual weapons, and brutality of the attacks of the Lansquenets had profound repercussions for Italian culture.

■ Sebastiano del Piombo, *Portrait of Pope Clement VII*, Gallerie di Capodimonte, Naples. Pope Clemente VII, nephew of Lorenzo the Magnificent, was profoundly shaken by the Sack of Rome, and in later portraits appeared suddenly aged, with a long beard and heavy eyes. It was he who commissioned Michelangelo to paint *The Last Judgment* in the Sistine Chapel.

A lost masterpiece: Death of St Peter Martyr

In 1528 Titian competed with Palma il Vecchio and Pordenone for the execution of a large altarpiece representing the killing of St Peter Martyr, intended for the Basilica Santi Giovanni e Paolo. Titian won the commission, thereby confirming his role of predominance within the Venetian art scene. Delivered on April 27, 1530, the altarpiece was one of his best works, as confirmed by Vasari in 1568: "It is the most accomplished, the most celebrated, the best understood, and the best executed work Titian ever created." At the beginning of the 17th century, art merchant Daniel Nys offered the incredible sum of 18,000 ducats to purchase it, but was turned down. Taken by Napoleon in 1797, it was returned to the Venetian church in 1816, but was completely destroyed in a fire on August 16, 1867. A few years later, critic Cavalcaselle commented, "No other work demonstrates the extraordinary power of Titian's mind as victoriously as this. This is an irreparable loss for art."

■ The great Gothic basilica dedicated to saints John and Paul – known commonly as "San Zanipolo" – is one of the richest and most prestigious churches in Venice. Built by Dominican friars, it houses splendid paintings by Giovanni Bellini, Veronese, and Lorenzo Lotto, as well as the monumental tombs of many illustrious Venetians. On its left side is the bronze equestrian monument to Bartolomeo Colleoni, a masterpiece of Renaissance sculpture by Andrea Verrocchio.

■ Jean-Honoré Fragonard, *St Peter Martyr (after Titian)*, 1760, Norton Simon Museum, Pasadena. Titian's great painting was admired and copied for centuries by artists from all over Europe. This drawing is one of the sketches executed by Fragonard during his stay in Italy between 1756 and 1761.

■ Giovanni Bellini, *Death of St Peter Martyr*, c.1500, Courtauld Institute, London. The killing of the Dominican saint is a recurring subject in Renaissance paintings.

■ This 17th-century engraving captures perfectly the same fury that animated Titian's masterpiece. During a tragic ambush in the mysterious forest, a hired killer stabs the saint while the other terrified friar turns to flee.

Titian, *The Presentation of the Virgin in the Temple*, 1534–38, Gallerie dell'Accademia, Venice

Titian and Aretino

Pietro Aretino, defined by his contemporaries as the "scourge of princes" and "secretary of the world", played a role of paramount importance in Titian's life and career: indeed, during their friendship of 30 years, he became almost the artist's "proxy". An indefatigable polemist and a feared and respected writer of libels, Aretino's fame as an intellectual spread all over Europe. Upon his arrival in Venice in 1527, Aretino moved into Ca' Bollani, a small building on the corner of Rio Santi Apostoli and the Grand Canal. From here he started writing letters, notes, poems, and all sorts of publications addressed to the powerful rulers of Europe. Aretino's rich collection of letters, which was successfully published several times, included 144 epistles addressed to Titian, who was also mentioned in 225 other letters. Thanks to his friend's excellent contacts and untiring promotional efforts, Titian gained privileged access to the courts of dukes, emperors, princes, and popes. Pietro Aretino was at the forefront of the harsh debate dividing Venetian art critics, who favored Titian and the use of color, and their Florentine counterparts, who supported drawing and Michelangelo. Indeed, in spite of his Tuscan origins, Aretino vociferously criticized *The Last Judgment* in the Sistine Chapel. Aside from the professional link, Titian and Aretino developed a deep friendship that grew to include architect Jacopo Sansovino as well. Aretino died suddenly on October 21, 1556.

■ Giulio Romano, illustrations for Pietro Aretino's book *Ways*. In spite of his extensive and varied literary output, which also included the pious *Lives of the Saints*, Aretino was considered first and foremost a writer of erotica. A rare volume illustrated by Giulio Romano on the different ways to have sexual intercourse caused such a great scandal that it was immediately banned for being pornographic. The volume, however, continued to circulate as a clandestine publication, sometimes even in the form of flyers.

■ Titian, *Portrait of Pietro Aretino*, 1545, Galleria Palatina, Florence. Titian portrayed his friend several times, and usually these paintings were sold to collectors or donated to noblemen. Unusually, this amazingly lively portrait was destined for Aretino himself. Unhappy with the experimental technique used by Titian, however, the writer defined this work as "roughly sketched rather than completed".

■ Titian, *St Mary Magdalene in Penitence*, 1531, Galleria Palatina, Florence. Painted for the Gonzaga family, this picture was so successful that Vittoria Colonna immediately ordered a version for herself. The subtle ambiguity between eroticism and devotion excited Aretino, who praised this work in his writings. He also incited Titian to create several copies, all of which were sold to various noble families at high prices.

1530-1540

Madonna of the Rabbit

Part of Louis XIV's Parisian collection, this work is housed in the Louvre. Painted in 1530, it may have been inspired by the untimely demise of Titian's wife Cecilia, who died in August 1530 after giving birth to their daughter Lavinia. The figure of St Catherine, shown as she is about to give the child to Mary, may be a portrait of Cecilia.

■ The workbasket, a delicate reminder of domestic duties, appears in an almost identical form in another painting by Titian, *The Annunciation*, which is kept in the Scuola di San Rocco in Venice (see opposite).

■ The shepherd in the background observes the scene without taking part in it. This melancholic figure is a self-portrait of the then 40-year-old Titian.

■ The Virgin Mary is caressing a white rabbit, a traditional symbol of fertility that can also be interpreted as a touching reminder of Cecilia's death. The tone of sadness is heightened by the sunset in the background.

■ Titian, *The Annunciation*, detail, c.1538, Scuola di San Rocco, Venice. On September 1, 1531, a year after Cecilia's death, Titian moved to Biri Grande on the eastern edge of Venice. He lived there until his death 45 years later.

1530-1540

Emperor Charles V

Born in Ghent in 1500, Charles V of Augsburg became emperor at a young age, in 1520, in dynastic succession to Maximilian I. His presence dominated the first half of the 16th century. This gigantic historical figure, who became involved in the fight between Catholics and Protestants, and who expertly ruled a vast empire that extended into two continents, was a small, pale, feeble man deformed by a strongly protruding jaw. Thanks to the intervention of Aretino and to a series of highly placed recommendations, Titian first came into contact with Charles V in February 1530, during the latter's solemn coronation ceremony in Bologna. Their rapport of mutual respect developed from that first meeting. Charles V became Titian's main patron, and in 1533 he gave the artist the title of Knight of the Golden Spur and free access to his court. Titian, in return, created enduring images of the Emperor and his family. The artist and the Spanish court became further linked by a long series of commissions, letters, and unpaid invoices. A great many of the works executed for Charles V and Philip II are today in the Museo del Prado in Madrid and the monastery of the Escorial.

■ Lucas Cranach the Elder, *A Stag Hunt*, detail, Museo del Prado, Madrid. The Emperor holds a crossbow during a hunt organized in his honor in the park of a German castle. Hunting was one of the few pastimes of Charles V, who was otherwise completely absorbed in his pressing political duties.

■ This grandiose bas-relief of the Virgin with Child by Nicolò dell'Arca is a decoration on the facade of Palazzo Accursio in Bologna. Charles V stood at a balcony in this building, on February 25, 1530, the day of his 30th birthday and of his solemn coronation.

■ The leaning Asinelli and Garisenda towers, in the heart of the city, are the historical symbol of Bologna.

■ Titian, *Scene of Reception,* c.1530, Musée des Beaux-Arts, Besançon. This quick sketch represents the first meeting between Titian and Charles V.

■ Titian, *Portrait of Charles V with his Dog,* 1532–33, Museo del Prado, Madrid. Painted during a short stay of the Emperor in Bologna, this is the oldest of Titian's surviving portraits of Charles V. The sovereign, almost crushed by his heavy attire, distractedly strokes an Irish setter. Titian chose the standing pose, a new format showing the full figure, which was an immediate success.

Works for the della Rovere family

Starting from 1532, and for more than ten years, Titian worked for Francesco Maria della Rovere, Duke of Urbino. The Duke was trying to revitalize the small court in the Marches that had enjoyed great success under the Montefeltro family. Titian was already engaged with official assignments from Venice, Charles V's requests, and his regular visits to the Gonzagas in Mantua, but he devoted particular attention to the della Rovere family. Today most of his works for the duchy are in Florence, including two portraits and the marvellous Venus, carried out for Guidobaldo II della Rovere. Sadly, other works mentioned in contemporary sources have since gone missing. Titian's relationship with the della Rovere family was not only lucrative but afforded him great prestige: in 1545, breaking his journey to Rome with a brief stay at the della Rovere court, the duke provided him with an escort for the rest of his trip.

■ Titian, *The Resurrection*, 1542, Galleria Nazionale delle Marche, Urbino. This is the front of the standard of the della Rovere family, which is today divided into two separate pieces. It is the only work by Titian still in Urbino. This scene represents with more composure the central panel of *The Averoldi Polyptych* in Brescia (see pp. 44–45).

■ The small towers of the Ducal Palace can be seen among the green hills on the unmistakable Urbino skyline.

LIFE AND WORKS

1530-1540

■ Titian, *Portrait of Francesco Maria della Rovere*, 1536–38, Galleria degli Uffizi, Florence. This is one of Titian's masterpieces of portraiture, perfect to the finest detail. For greater accuracy, Titian asked for the armor to be sent to him. In order to avoid any damage to it, the Duke sent a sergeant to the painter's studio to collect it.

■ Titian, *Portrait of Eleonora Gonzaga*, 1536–38, Galleria degli Uffizi, Florence. The wife of Francesco Maria della Rovere (the portraits were conceived as a pair) was Isabella d'Este's daughter, the sister of Federico Gonzaga of Mantua.

■ Titian, *The Last Supper*, 1542, Galleria Nazionale delle Marche, Urbino. This is the reverse of the banner that depicts *The Resurrection* on the front.

Venus of Urbino

Executed in 1538 for Guidobaldo II della Rovere, this work was moved from Urbino to Florence in 1631, and is still housed in the Galleria degli Uffizi. Admired for centuries, it has had a great influence upon many artists.

■ Edouard Manet, *Olympia*, 1863, Musée d'Orsay, Paris. For this work, Manet, the most cultured and classical of the Impressionists, openly drew inspiration from Titian, especially in portraying the seductive nature of the character.

■ Titian, *Girl in a Fur*, 1536, Kunsthistorisches Museum, Vienna. The girl in this painting is clearly the same model used for the *Venus of Urbino*. Here Titian introduced an ideal of female beauty that was quite different from the one he had exalted in his younger years.

■ Titian, *La Bella*, 1536, Galleria Palatina, Florence. Another painting of the same model – this time richly attired – who may have been a young woman from Ferrara living in Biri Grande in about 1536. Her dark, deep eyes, slim figure, and auburn hair place her in direct contrast with the voluptuous blonde women with big, blue eyes portrayed in Titian's earlier works.

■ Francisco Goya, *Naked Maja*, 1797–1800, Museo del Prado, Madrid. Titian's *Venus* was an immediate success, as well as being the inspiration behind some of the most famous works of European art.

The "Etruscan demons" of Mannerism

■ Titian, *Christ Crowned with Thorns*, 1542–44, Musée du Louvre, Paris. Painted for the church of Santa Maria delle Grazie in Milan, this altarpiece is Titian's most eloquent response to Mannerism. The perturbed dynamism, gigantic anatomies, contrived gestures, and the homage to antiquity in the bust of Tiberius, are elements typical of Michelangelo. Titian, however, also inserts the expressive richness of color.

The Venetian art school followed a coherent development from Giovanni Bellini through Giorgione to Titian; it also reflected the personality of a city that had managed to avoid conquests and lootings from abroad. At the end of the 1530s, however, Venice had to bow to the sweeping success of Mannerism. Developed in about 1520 as a reaction against humanistic rules of composition, Mannerism had grown in Florence and Rome. Once the initial controversial stage had passed, it became the official style in Italy and Europe, thanks especially to the travels of Raphael's students and various Tuscan painters. Michelangelo's heroic monumentality, the exaggerated gestures, the rapport with antiquity, and the contrived elegance of the artistry were fundamental elements of the style, which was also supported by writers and art critics. In about 1540 two influential Tuscan artists, Francesco Salviati and Giorgio Vasari, arrived in Venice and their works immediately attracted the attention of local young painters, such as the 20-year-old Tintoretto and Jacopo Bassano. Not wishing to withdraw from the challenge, Titian postponed his trip to Rome by a few years in order to stay in Venice.

■ Lorenzo Lotto, *St Antoninus Altarpiece*, 1540, San Zanipolo, Venice. This is one of the few requests Lotto received from his hometown. Neither Titian nor Aretino had much admiration for Lotto. Slowly he was cast out of artistic life and died in poverty.

■ Titian, *The Allocution of Alfonso d'Avalos*, 1540, Museo del Prado, Madrid. Alfonso d'Avalos, Marquis of Vasto and Pescara, and Spanish Governor in Milan, is portrayed here in a classic authoritative and formal pose as he addresses his soldiers. The warm light shining on the clothes and armor heightens the deliberately Mannerist tone of the scene.

■ Pordenone, *Altarpiece of the Blessed Lorenzo Giustiniani*, 1532, Gallerie dell'Accademia, Venice. An expert in Tuscan and Roman art, Pordenone was Titian's main rival for supremacy within the Venetian school in the 1530s.

Titian, *Portrait of Count Antonio Porcia*, c.1540, Pinacoteca di Brera, Milan

Titian in Rome

I n about 1542, Titian came into contact with the Farnese family, which became extremely powerful after one of its members, Paul III, was elected pope. As usual, the relationship was helped by a series of fortunate circumstances: an ambitious client, Cardinal Alessandro Farnese; Pietro Aretino's mediation; and important historical events, such as the first talks between the Pope and Charles V to start the Council of Trent. After organizing his studio and his travel arrangements, in September 1545 Titian went to Rome, accompanied by his son Orazio, and took residence in an apartment overlooking the gardens of the Vatican. The Roman artistic milieu, dominated by Michelangelo and Mannerism, was hostile to the Venetian artist: the bright naturalness of his colors was too different from the cerebral rigor of the Mannerists. Even Michelangelo, who observed Titian as he was completing the *Danaë*, criticized his lack of interest in drawing. The stay in Rome gave Titian the chance to study both modern and old works of art up close, but it also helped him overcome any awe towards classicism. After this visit, Titian's Mannerist phase was over.

■ Titian, *Portrait of Ranuccio Farnese*, 1542, National Gallery, Washington. The portrait of this 11-year-old boy, future Duke of Parma and Piacenza, started Titian's professional rapport with the Farnese family.

■ Titian, *Danaë*, 1545, Gallerie di Capodimonte, Naples. This masterpiece of sensuality, defined as "a nude capable of turning people to sin", was painted in the Vatican for Cardinal Alessandro Farnese.

■ Titian, *Portrait of Pope Paul III,* 1545, Gallerie di Capodimonte, Naples. This private portrait of the Pope was another apparently remarkable likeness. The simple, direct pose, devoid of particular surroundings or descriptive notes, was adopted for centuries as a model for papal portraits.

■ Titian, *Portrait of Cardinal Alessandro Farnese,* 1543, Gallerie di Capodimonte, Naples. Alessandro Farnese was ambitious, ingratiating, power-hungry, and lavish of promises. The perfect example of nepotism, he was for years one of Titian's main patrons. Almost all of Titian's paintings for the Farnese family are in Naples, where the extraordinary art collection of the family was transferred in the 18th century.

79

1540-1551

Pope Paul III and his Nephews

This painting, Titian's main work for the Farnese family, dates from 1545 and is housed in the Gallerie di Capodimonte in Naples. Next to the ageing Pope Paul III are his nephews, Cardinal Alessandro and the young Ottavio.

■ Clocks are a recurrent feature in Titian's works of the 1530s and 1540s: he collected these precious objects.

■ Cardinal Alessandro tightly grips the knob of the Pope's chair, indicating a desire for control, which is disguised by his look of complete innocence. Titian's penetrating insight into the characters makes this triple portrait one of his finest masterpieces.

■ The unctuous bow by Ottavio is a parody of the *Discobolus* by Myron. Titian's disenchanted and irreverent attitude towards classical art is in direct opposition to the absolute adoration by the Mannerists. These little touches, as well as the mellow richness of the colors, reveal the difference between the artistic beliefs of the Venetians, and those of the painters and writers in Tuscany and Rome around the mid-1500s.

■ The hands of the Pope are barely sketched, completed with just a few brushstrokes. Titian was already experimenting with this technique of the "unfinished", which he explored to the full in his old age.

The Reformation: the Council of Trent and the Diet of Augsburg

The end of the troubled division between Catholics and followers of Martin Luther came in about 1550. The Protestant schism had started in 1520 and developed along two channels: the religious one, which witnessed the development of the Reformation according to the doctrines of Melanchthon and Calvin, and the political one, which saw a contrast between German Protestant princes and Emperor Charles V, defender of Catholicism. The Council of Trent, called by Pope Paul III, was the answer to the need for reform within the Catholic church, a reform that had been initiated by the great humanist Erasmus. The Council effectively put an end to the further expansion of Protestantism. The Diet of Augsburg, instigated by Charles V in 1548 after the victorious Battle of Mühlberg, ended with an agreement between the factions and the affirmation of the principle of freedom of worship. Titian, by then a figure of international prestige, took part in the meetings of the Diet in 1548 and 1551; on both occasions, he was lodged near the Emperor's apartment. In 1548 he had been forced to leave in a hurry, in the middle of winter, leaving Aretino in charge of his studio. In 1551, however, Titian's sojourn was expertly organized by the powerful Cardinal Perrenot de Granvelle.

■ Hans Holbein, *Portrait of Erasmus*, Musée du Louvre, Paris. The Dutch humanist Erasmus was one of the first to solicit a profound reflection on religion.

■ Lucas Cranach the Elder, *Portrait of Martin Luther*, Museo Poldi Pezzoli, Milan. This is one of the many propagandist portraits executed by Cranach, a strict Lutheran.

■ Titian, *Portrait of Charles V Seated*, 1548, Alte Pinakothek, Munich. A private and touchingly human picture of the Emperor, this painting is at odds with his victorious equestrian portrait (see pp. 86–87). Here the sovereign appears prematurely aged, marked by fatigue and suffering from gout.

■ Giovanni Battista Moroni, *Altarpiece of the Doctors of the Church*, detail, Santa Maria Maggiore, Trent.

■ Titian, *Portrait of John Frederick of Saxony*, 1548 or 1551, Kunsthistorisches Museum, Vienna. The Elector of Saxony was the leader of the Protestant troops in the League of Schmalkalden. After his defeat by Charles V at Mühlberg, he took part in the meetings of the Diet of Augsburg in the difficult role of loser. Titian's portrait reveals the anxious yet noble psychology of his character.

■ Titian, *Portrait of Cardinal Cristoforo Madruzzo*, c.1543, Museu de Arte, São Paulo. The host of the Council, the Bishop of Trent, was portrayed by Titian as a busy intellectual: on his desk is another example of an ornamental clock.

1540-1551

Pope and Emperor

Titian reached the height of his international fame in the mid-16th century. After having his presence requested by the Pope in Rome and the Medici family in Florence (1545–46), and being a welcome guest in Augsburg, near Charles V (1548 and 1550–51), Titian rediscovered the provincial charm of Pieve di Cadore. He increasingly spent time here, helping in the development of some paintings for local churches. The most sought-after works from the 60-year-old painter were portraits, a genre in which he excelled. He also executed sacred works and an increasing number of mythological compositions: the latter, however, were executed with a very different spirit from that animating the paintings of his youth. As he approached old age, Titian interpreted the classic – and often tragic – stories of the heroes and gods of mythology as poetic and dramatic examples of the eternal cycle of human destiny.

■ Titian, *Portrait of Isabella of Portugal*, 1548, Museo del Prado, Madrid. This disquieting and fascinating painting portrays Charles V's wife, who, in 1548, had been dead for ten years. Titian used an old portrait as a model to create this ethereal image of the queen.

■ Titian, *Votive Portrait of the Vendramin Family*, 1543–47, National Gallery, London. This large painting of the male members of this noble family was deliberately left unfinished when Titian left for Rome. He completed it on his return, in order to confirm his position of supremacy within the Venetian art scene.

■ Titian, *Venus and an Organist*, 1550, Museo del Prado, Madrid. This was one of Titian's most profitable paintings: the prototype (also in the Prado) was given to Cardinal Perrenot de Granvelle by Charles V.

■ Titian, *Portrait of a Knight of Malta*, c.1550, Museo del Prado, Madrid. This character, who appears to be touching an ornamental clock, could be Giannello Della Torre from Cremona, court watchmaker in Madrid.

■ Titian, *The Adoration of the Holy Trinity*, 1551–54, Museo del Prado, Madrid. This large and complex allegorical work was commissioned by Charles V who appears, center right, kneeling in prayer with his family. The Emperor never parted with this work, and even took it with him when he went in voluntary exile to the monastery of St Jerome of Yuste, after abdicating in favor of his son Philip II.

1540-1551

Charles V at Mühlberg

Painted in 1548 and housed in the Prado in Madrid, this work celebrates the Emperor's victory over the German Protestants in the Battle of Mühlberg (1547). For centuries it was the model for equestrian celebratory portraits.

■ Under his helmet, Charles V's unpleasant features are illuminated by a look of single-minded determination. His fiery eyes and tight jaw create a very different image from the one of tired frailty represented in the seated portrait (see p. 82).

■ Charles V's elaborate battle dress, decorated with a crimson sash, was a masterpiece of engraving by Milanese armorers. Titian has skilfully captured the reflective sheen of the armor as it glints in the setting sun.

■ Through the forest, the sunset can be seen lighting up the landscape with the dramatic intensity of a fire. Titian often used this kind of light to give his characters and scenes a sense of inevitable fate.

A new generation of Venetian painters

Titian dominated the Venetian art scene for decades, overwhelming anybody who competed against him, from Sebastiano del Piombo to Pordenone and Lorenzo Lotto. As he approached his sixties, he witnessed the emergence of a new generation of young artists, who, although influenced by Mannerism, were eager to work within the local tradition. One of the most remarkable of the new artists was the 30-year-old

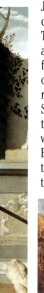

Jacopo Tintoretto, whose ambition was to combine Michelangelo's drawing skills and Titian's use of color. Titian considered him a dangerous rival and never offered his friendship to him. Paolo Veronese, on the other hand, was often praised and rewarded publicly by the old maestro. Some artists, like Schiavone, continued to create works in the Mannerist style, while other provincial painters (Jacopo Bassano, Giovanni Battista Moroni, and the school of Brescia) developed a strong trend towards realism.

■ Andrea Schiavone, *Adoration of the Magi*, Pinacoteca Ambrosiana, Milan. The twisted columns and spiral poses in this work recall Tuscan and Roman Mannerism.

■ Giovanni Battista Moroni, *The Knight in Pink*, Collezione dei Conti Moroni, Bergamo. This portrait artist from Bergamo constituted a suitable alternative to Titian for the middle nobility.

■ Jacopo Bassano, *Rest on the Flight into Egypt*, Pinacoteca Ambrosiana, Milan. The popular realism in the works of Jacopo Bassano represents one of the most exciting aspects of the new Venetian school.

■ Jacopo Tintoretto, *St Mark Rescuing a Slave*, detail, Gallerie dell'Accademia, Venice. Publicly exhibited in the noble Scuola di San Marco in 1548 while Titian was in Augsburg, this painting gave Tintoretto immediate fame. It also attracted the interest of Pietro Aretino and the friendship of Jacopo Sansovino.

■ Paolo Veronese, *Mystic Marriage of St Catherine*, Gallerie dell'Accademia, Venice. Veronese's sacred scenes are vibrant spectacles of color and joy. The columns here are similar to those of *The Pesaro Altarpiece* (see pp. 56–57).

The "poesie" for Philip II

At the beginning of the 1550s Titian found a new patron in Philip II, who became emperor in 1555 following the abdication of his father Charles V. Frail and timid, the prince began a correspondence with Titian, who, starting in 1553, executed seven mythological paintings for him. These works, which Titian defined as *poesie*, or "painted poems", are now scattered in museums across the world. Unlike the joyous bacchanals executed 35 years earlier for Duke Alfonso d'Este, the pagan pictures of the 1550s were the result of a phase of intense and moving reflection on the human condition. Inspired by ancient myths, Titian went beyond the mere representation of the words of Ovid and other classical authors: he interpreted the destinies of the characters as bitter metaphors for life, in which humankind is left at the mercy of fate and circumstance. The new stylistic elements and the exceptional intensity of his paintings were the ideal support for this frame of moral significance. Painted especially for the Spanish court, Titian's *poesie* were soon successfully copied.

■ Leone Leoni, *The Family of the Emperor*, Church of the Monastery of the Escorial, Spain. The two grandiose groups of bronze statues representing the families of Charles V and Philip II are the masterpieces of this sculptor from Arezzo. Leoni worked at the Spanish court for several years.

■ Titian, *Venus and Adonis*, 1553, Museo del Prado, Madrid. This was the first of Titian's *poesie* for Philip II. The goddess Venus is desperately trying to stop her beloved from going on the hunt in which he will meet his death, killed by a wild boar. The imminent tragedy is underlined by the approaching storm in the background, and by the complete unawareness of Cupid who has fallen asleep in the woods. This sleep, a remarkable detail, carries an intense moral significance: it was Cupid's arrow that wounded Venus causing her to fall in love with Adonis, and it is also Cupid who now increases her suffering by his carelessness.

■ Titian, *Death of Actaeon*, c.1559, National Gallery, London. In the final act of the dramatic tale of Actaeon, he is transformed into a deer, and savaged by dogs. The athletic goddess Diana, indifferent to his tragedy, continues her hunt in a stormy landscape that seems to echo the horrible events.

■ Titian, *Rape of Europa*, 1559–62, Isabella Stewart Gardner Museum, Boston. In this, the last of the *poesie*, Titian shows Europa kidnapped by Zeus disguised as a white bull. Europa tries desperately to fight her destiny, but she is dragged away from her friends, who watch helplessly from the shore.

93

BACKGROUND

Venice: "a noble and unique city"

In the space of fifty years, from the beginning of the 16th century until the mid-1500s, the urban landscape of Venice changed radically. The delicate, ornate elements typical of the late Gothic and the early Renaissance were overcome by a new, vigorous trend of classicism. Introduced by Doge Gritti in about 1520, classicist architecture found its greatest interpreter in Jacopo Sansovino, who was for years the Republic's official architect, or *Protomastro*. He created some of the buildings that remain the embodiment of Venice, like the Library of St Mark, and the Loggetta at the foot of the Campanile. Another great architect of this period was Palladio, author of some of the most important Renaissance churches in Venice, such as Il Redentore, San Giorgio Maggiore, and San Francesco della Vigna. The new trend of classicism also inspired some spectacular changes on the Grand Canal, including the Rialto Bridge. Thanks to the architectural creations of the 16th century, Venice became known not as the heir to Byzantium or Rome, but as a city without equal anywhere in the world. Indeed, "A noble and unique city" became the title of the first tourist guide of Venice, written by the Francesco Sansovino, Jacopo's son, and published in 1581. However, after the death of the main architects – Sansovino in 1570, Palladio ten years later – the classicist phase was over.

■ The architectural creations of Jacopo Sansovino, like the front of the Library of St Mark, came to represent the essence of Venice, as shown by Canaletto's panoramic views.

■ Even during its classicist phase, Venice maintained its joyous, appealing image. This 16th-century engraving represents the passage of the debutantes in a gondola on the Grand Canal.

■ Paris Bordone, *The Ceremony of the Doge's Ring*, c.1534–35, detail, Gallerie dell'Accademia, Venice. Among the artists of the Veneto, Paris Bordone was the most responsive to the architecture of the mid-16th century. Some of the local buildings appear in his paintings, albeit creatively reworked.

■ Jacopo Tintoretto, *Portrait of Jacopo Sansovino*, Galleria Palatina, Florence. From 1529 until his death in 1570, Jacopo Sansovino was the official architect of the Republic. Among other things, he was in charge of all the building yards in Venice.

■ Titian, *Portrait of Doge Francesco Venier*, 1555, Thyssen Collection, Madrid. Elected in old age in 1554, Doge Venier died two years later. During his office he requested several works from Titian. The official portrait was destroyed in the fire of the Doges' Palace in 1577: only this private image of a serene, frail man, remains.

Venus with a Mirror

Painted in 1555 and housed in the National Gallery in Washington, this is one of the most splendid works produced by Titian in his old age. It may have been inspired by the wedding of his daughter Lavinia.

■ Giovanni Bellini, *Woman with a Mirror*, 1515, Kunsthistorisches Museum, Vienna. The theme of a girl at the mirror was introduced both by Giorgione and this final work by Bellini.

■ Titian, *Young Woman at her Toilet*, 1516, Musée du Louvre, Paris.

The "excellence of art" reflected in a mirror

Early in his career, Titian included mirrors in his paintings of female half-figures, which were created mainly for private collectors. Increasingly, the mirror image was employed by painters in the contemporary debate over which was the ideal art form – sculpture or painting. To the sculptors' claim that their three-dimensional works came close to perfection, Giorgione replied with a now-lost painting of a figure, surrounded by mirrors, visible from every angle. The trend of the mirror image also influenced Savoldo, author of a portrait housed in the Louvre in which the character points at himself in the mirror.

■ Diego Velázquez, *The Toilet of Venus* (*"The Rokeby Venus"*), 1650, National Gallery, London. Titian's use of the mirror image was influential in the 17th century: it inspired Rubens and Velázquez, among others, to create some of their best works.

The Treaty of Cateau-Cambrésis

A fter signing the Peace of Augsburg with the German princes, Charles V decided to retire from politics. Abdicating in 1556, he divided his empire into two portions – the kingdoms of Spain and Austria – and left his son Philip II the largest part. The great emperor, aged before his time, retired to the monastery of St Jerome, in Yuste, where he took some of his favorite paintings by Titian, including *The Adoration of the Holy Trinity* (see p. 85) and the portrait of his wife (see p. 84). To the latter, Charles V is said to have devoted his final glance before dying. Philip II immediately had to deal with a difficult issue, namely the alliance of Pope Paul IV Carafa with King

■ This illuminated register cover was created in Siena, and represents the embrace between Henry II of France and Philip II after the Treaty of Cateau-Cambrésis.

Henry II of France. This alliance had been created to stop the expropriation of church properties in Protestant German territories, where Charles V had granted freedom of worship. Emanuel Filibert of Savoy, who was leading the imperial troops, defeated the French in the Battle of St Quentin in 1557. Charles V died in solitude on September 21, 1558 and a new balance of power in Europe was agreed in the Treaty of Cateau-Cambrésis (1559). Following this signing, Spain built the "invincible" Armada, a powerful fleet of huge battle galleons, and concentrated its maritime power against the Turks (at the Battle of Návpaktos) and the English.

■ Andrea Vicentino, *The Arrival in Venice of the King of France*, Palazzo Ducale, Venice. Upon landing, the King of France is welcomed by the doge and the patriarch of the city, while a procession of dignitaries queues under an arch of papier-mâché designed by Palladio.

■ This 16th-century engraving shows the imposing structure of the Escorial. Created by Philip II after the Battle of St Quentin, it was built in the shape of a grill in honor of St Lawrence.

■ Philip II's bedroom in the Escorial. The royal apartment was expressly simple. It was inserted within the solemn, yet gloomy building of the monastery, which had been specifically chosen as tomb for the Spanish royal family by Philip II.

■ Titian, *Portrait of Philip II*, 1551, Museo del Prado, Madrid. Executed during the Diet of Augsburg, this is the first and most flamboyant of Titian's portraits of the heir to Charles V. The frail and troubled prince appears almost crushed by the shining gala armor, which is still kept in the Royal Armory in Madrid.

Sacred and profane

Towards the end of the 1550s, a series of events heightened the sense of solitude and mortality weighing on Titian's soul. These events were the death of Pietro Aretino in October 1556; the wounding of Titian's son Orazio, stabbed in Milan in 1557 by Leone Leoni, who wanted to rob him of 2000 scutes; and the deaths of Charles V in 1558 and his own dear brother Francesco the following year. Titian reacted by immersing himself in painting: engaged in many difficult commissions for the Spanish court, these years were a period of exuberant creativity. He devoted less time to portraits, and instead created altarpieces, mythologies, and sacred and profane allegories. His greatest work of this period is the altarpiece of *The Martyrdom of St Lawrence* (see pp. 102–03). Started in 1548 and completed only ten years later, this grandiose work featured a new and anticomformist technique. The intense passion of the sacred art created by Titian in these years was directly related to the developments in the religious debate. As the Council of Trent approached its final stages, in 1559 the Pope Inquisitor Paul IV Carafa published the *Indice*, an index of banned books. All of Pietro Aretino's writings were listed within.

■ Titian, *St Jerome in the Wilderness*, c.1552, Pinacoteca di Brera, Milan. This wild and dramatic natural landscape is reminiscent of the lost *Death of St Peter Martyr*.

■ Titian, *Madonna and Child in Glory, and Saints Peter and Andrew*, 1547, Duomo, Serravalle di Vittorio Veneto. Originally entrusted to Francesco Vecellio, this altarpiece was partly executed by his more famous brother. Titian asked for and obtained a generous raise of the agreed payment. His daughter Lavinia moved to Serravalle after her wedding.

■ Titian, *Wisdom*, 1559, Libreria Marciana, Venice. This beautiful allegorical figure, painted after all the decorative work for Sansovino's building had been completed, graces the ceiling of the entrance hall. Seven artists took part in a contest organized to choose who would paint the ceiling of the reading room: Titian, the juror, declared them all equal winners. However, he gave Veronese a golden necklace as a sign of his preference.

■ Titian, *St Margaret and the Dragon*, c.1560, Museo del Prado, Madrid. This is a modified and more dramatic version of a painting Titian had sent to the court of Spain ten years earlier.

The Martyrdom of St Lawrence

Commissioned by the nobleman Lorenzo Massolo for his funerary chapel in the Chiesa dei Crociferi, Venice, this altarpiece was finished in 1558–59. It is still in its original location, which is known today as Chiesa dei Gesuiti

■ This mysterious figure, emerging from the dark, stands at the edge of the scene, seemingly unaware of the gruesome events taking place below.

■ The dark, cloudy sky is torn open by a bolt of lightning. This contributes to the fantastic and dramatic use of lights in this work, which has been described as one of the most evocative nocturnes in the history of art. Ten years passed between the beginning of this altarpiece and its completion. The long period of development is justified by the aforementioned revolutionary use of light, and by the painful identification between painter and subject. Titian later executed a replica of this altarpiece for the main altar of the Escorial.

■ The armor and helmets of the soldiers reflect sparks of light, an effect obtained by strokes of bright white. This work features different painting styles – from extremely detailed drawing, to a few, dramatic strokes of color.

■ Titian's signature, and his title of rank of imperial knight, "*eques cesareus*", appear on the grill of martyrdom. The fire under the grill was defined by Vasari as "thick and very lively", a comment that focused on the physical consistency of this element and its almost palpable presence. The *Martyrdom of St Lawrence* altarpiece is the key to understanding the splendid last phase of Titian's art – a phase in which he achieved complete control over light and color.

Titian and his studio

After turning 70, Titian operated a distinct division of his activities: on one hand he devoted himself with eagerness and passion to creating some of his best works; on the other, he reorganized his studio according to the entrepreneurial spirit that had dominated his whole career. During this period Titian put his signature on many paintings, ranging from replicas to variations of successful compositions. In reality, however, these works were often created by his collaborators, and Titian claimed them as his own by only a few brushstrokes – as complained a contemporary art dealer. It should be noted that Titian usually chose students of limited talent, unable to develop their own, individual style. Tintoretto stayed in the studio for ten days before being evicted; the apprenticeship of the talented Domenicos Theotokopoulos from Crete, who became famous as El Greco, did not last much longer. To replace Aretino as his agent, Titian employed Verdizzotti, a literary man who later wrote the painter's biography. In 1566 Titian introduced the concept of copyright by giving two engravers, upon payment, the right to create prints from his paintings.

■ El Greco, *Christ Healing the Blind*, Galleria Nazionale, Parma. A typical early work of the artist, this painting shows the influence of the Venetian school.

■ Titian and studio, *The Last Supper*, c.1560, Pinacoteca di Brera, Milan. Although it was considered a copy for many years, this is likely to be a sketch for the large *Last Supper* sent to the Escorial in 1564, which was reduced (and damaged) to fit the wall of the monastery there.

The case of St Mary Magdalene in Penitence

In 1561 Titian sent to Philip II a "dishevelled Mary Magdalene who […] although beautiful, does not move to lust, but pity" (Vasari). This painting was immediately extremely successful, but it has not yet been traced. There are, however, numerous signed replicas and copies. This is a typical example of the production of Titian's studio. Among the many versions, the most worthy of praise are the one at the Hermitage in St Petersburg (shown here on the left, with the crystal vase), and the one at the Gallerie di Capodimonte in Naples (on the right), of lesser quality.

■ Titian, *The Crucifixion*, c.1565, Monastery of St Lawrence, Escorial. This large painting reflects the typical gloomy atmosphere of the sacred paintings commissioned by Philip II. In about 1560 Titian handled the theme of the Crucifixion in many ways and formats, from the altarpiece of the Chiesa di San Domenico in Ancona, to the minuscule portable version now kept in the Escorial.

The art dealers

In the 1560s Titian promoted the development of a new profession: the art dealer. Before him, the transaction between the artist and buyer was either direct, or entrusted to a well-known agent. Titian's universal reputation and the immense productivity of his workshop, however, called for a third party to regulate the sale of works not specifically commissioned by a collector. During this decade, three dealers competed for Titian's paintings: Jacopo Strada, the Flemish Han van Haanen, and Nicolò Stoppio, who in good humor defined the situation as "three gluttons around a chopping board". Noble and cultured, these characters strongly influenced both the artistic taste of the time and critical judgments: Nicolò Stoppio, unable to obtain any work by Titian, claimed that the painter was old, his hand shaky, his sight faltering, and that his latest paintings had little worth.

■ Vittore Carpaccio, *The Vision of St Augustine*, detail, 1498, Scuola di San Giorgio degli Schiavoni, Venice. This work contains one of the first images of the studio of a Renaissance art collector: books and art objects are orderly displayed on the shelves.

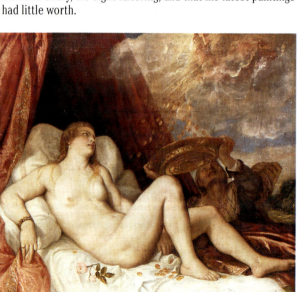

■ Titian, *Danaë*, 1554, Kunsthistorisches Museum, Vienna. Acquired by Emperor Rudolph II of Augsburg, this is a modified version of the *Danaë* painted for the Farnese family ten years earlier. Titian's mythological and pagan paintings, especially those with a touch of eroticism, were in great demand in the collectors' market.

■ Titian, *The Fall of Man*, c.1565, Museo del Prado, Madrid. Damaged by a fire in 1734 and restored, this painting is an example of the "indirect" art market. Over a period of years, several copies were made of this work (including one by Rubens), all of which were fiercely competed for by collectors.

■ Jacopo Bassano, *Christ Evicting the Merchants from the Temple*, detail, National Gallery, London. Due to his openly commercial attitude, Titian is here portrayed as a greedy money-lender.

■ Titian, *Madonna and Child*, c.1560, Thyssen Collection, Madrid. This painting is a welcome return to the theme of the Madonna with Child, which Titian had hardly dealt with since 1530, when he painted *Madonna of the Rabbit* (pp. 66–67).

Portrait of Jacopo Strada

This portrait of art dealer Strada, Titian's personal friend, dates from 1567 and is housed in the Kunsthistorisches Museum in Vienna. The inscription on the upper right corner was added later, but is correct.

■ The face of Jacopo Strada reveals the probing intelligence and business acumen of this antique dealer. Born in Mantua, Strada had many illustrious people among his clients, such as the Pope, Emperor Maximilian II of Augsburg, and the Fugger family, famous German bankers.

■ With an expert touch, the art merchant shows an unseen client a beautiful classic statuette, a copy of a Venus by Praxiteles.

Titian successfully portrays a sense of delicacy and gentleness in the hands of the antique dealer.

■ The sword indicates the aristocratic status of Strada – it was also a sign of distinction and lineage. Strada's son also became an art dealer. His portrait, painted by Tintoretto, is housed in the Rijksmuseum in Amsterdam.

The sacred art of the Counter-Reformation

The Council of Trent came to a solemn close in 1563. Among one of the most urgent measures was the reform of sacred images: painters were advised to communicate the meaning of the scenes in a direct, emotional way, designed to illustrate examples of virtue. Particularly sensitive to the subject of sacred art were the new religious orders, such as the Jesuits, which had developed to give Catholic faith a new burst of energy. Early and yet extraordinarily effective examples of the sacred art of the Counter-Reformation is the series of large paintings by Tintoretto: the largest and most complex is the work at the Scuola di San Rocco, started in 1564 and completed, in successive stages, in the 1580s. The tribunal of the Inquisition exercised a very tight control over the representation of religious images. Venice, once the champion of tolerance and democracy, contributed to the dispute with some debatable actions, such as the inquest in 1573 into a large painting by Veronese (*The Feast in the House of Levi*, Gallerie dell'Accademia, Venice), considered almost heretical for its excessive number of characters and descriptive details. The work, executed for a Dominican convent, was meant to replace a *Last Supper* by Titian that had burnt in a fire during the Battle of Návpaktos, when the canteen was being used as an arsenal. There were still many religious issues to be solved: the whole of Europe was horrified by the news of the massacre of the French Huguenots on the "night of St Bartholomew" in 1572.

■ El Greco, *Portrait of Cardinal Niño de Guevara*, Reinhart Foundation, Winterthur.

■ Alessandro Buonvicino, called Moretto, *Christ and the Angel*, Pinacoteca Tosio Martinengo, Brescia.

■ Titian, *The Adoration of the Magi*, c.1560, Pinacoteca Ambrosiana, Milan. This changed version of a painting sent to the Escorial in 1559 is generally attributed to Titian. It was purchased by Cardinal Federico Borromeo, who, in 1618, founded the Ambrosiana Gallery.

■ Jacopo Bassano, *The Carrying of the Dead Christ*, Santa Maria del Vanzo, Padua. Bassano's paintings are animated by a robust sense of realism and often revolve around themes of popular devotion.

■ Jacopo Tintoretto, *The Removal of the Body of St Mark*, Gallerie dell'Accademia, Venice. Painted for the Scuola di San Marco (1562–66), this work has unusual perspectives and light effects.

■ Titian, *The Entombment*, 1566, Museo del Prado, Madrid. This dramatic work, full of pathos and choral participation, can be compared to the several versions of the *Pietà* sculpted by Michelangelo just before his death in 1564.

The meeting with Giorgio Vasari

iorgio Vasari, a painter and architect from Arezzo, wrote one of the most famous texts on Italian art, *Lives of the Most Excellent Painters, Sculptors, and Architects*. After the first edition, in 1550, Vasari felt the need to revise his book and, in order to collect more information for the second edition, he went to Venice in 1566. An essential stop during his journey was a visit to Titian's studio in Biri Grande, where he "found him, although very old, with brushes in his hand, engaged in a painting". Faced by an exciting gallery of works "sketched or started", Vasari was forced to shed all his Tuscan prejudices about the art of Titian. Following his visit, Vasari demanded that the painter be elected at the Accademia del Disegno in Florence, and in the new edition of *Lives* wrote: "He deserves to be loved and observed by all artists and, in many aspects, admired and imitated as someone who has created and still creates works of infinite praise. His paintings will be remembered as vividly as the deeds of illustrious men."
The second edition of *Lives*, published in 1568, is one of the main sources of information on the life and works of Titian, along with *Dialogo* by Ludovico Dolce (1557) and the numerous letters by Pietro Aretino. On the whole, Titian is one of the few Renaissance artists whose biographical and artistic development can be followed closely, thanks to excellent first-hand documents.

■ Titian, *Madonna and Child between Saints Titian and Andrew*, 1566–68, Chiesa Arcidiaconale, Pieve di Cadore. Mentioned by Vasari as one of the works in progress, this small altarpiece includes the artist's self-portrait, on the left, behind the patron saint.

■ Titian, *The Doge Antonio Grimani before Faith*, detail, 1555–76, Palazzo Ducale, Venice. Titian was very slow in delivering his paintings: this portrait was still in his studio when he died, 20 years after the work had been commissioned. It was therefore spared from the fire of the Doges' Palace in 1577, and, once completed by his students, was placed in its intended site.

■ Titian, *Allegory of Prudence*, 1566, National Gallery, London. This unique painting presents a triple portrait of Titian, his son Orazio, and his grandson Marco. They symbolize past, present, and future, and are placed in relation to the muzzles of a wolf, a lion, and a dog.

■ Titian, *Spain Coming to the Aid of Religion*, 1534–71, Museo del Prado, Madrid. Among the works admired by Vasari in Titian's studio was a "Triumph of Virtue over Vice", sketched for Alfonso d'Este, whose death in 1534 caused Titian to leave it unfinished. He returned to it 35 years later, transforming it into an allegory, which he sent to Philip II in 1575.

1560-1570

The Annunciation

This work, executed in 1566, is still in its original location in the Chiesa di San Salvador in Venice. More than four metres (12 feet) high, it is one of the last altarpieces completed solely by Titian.

■ El Greco, *The Annunciation*, 1573–76, Thyssen Collection, Madrid. Titian's large altarpiece had an immediate influence on painting in the Veneto: many artists gave the Annunciation a new, dramatic interpretation, filled with foreboding.

■ The flight of the angels, rendered by the superimposition of rich, creamy colors, has a thick and almost tangible feel. Here one can clearly see the technique Titian used to spread the paint – directly with his fingers, and not with a brush.

■ The "lost profile" of the angel is brought to life by the flickering contour and by the vibrant red colors surrounding it.

■ The allusion to the burning bush, symbolizing the Immaculate Conception, is made clearer by the inscription "*Ignis ardens non comburens*" – a fire that burns, but does not consume.

■ The authenticity of the signature is debatable. By the repetition of the word *fecit*, from the verb "to make", the 80-year-old Titian seems to be underlining with proud energy yet another fruit of his exceptional creativity.

TITIANVS FECIT FECIT

117

Titian, *The Punishment of Marsyas*, 1570, National Gallery, Kromeriz

A terrible and sublime old age

A lonely man
facing eternity

Jacopo Sansovino, Titian's last true friend, died in 1570, when he was 84 years old. As slowly as possible, Titian started working on the painting that was to decorate his own tomb and thinking about his succession. He made a will, demanded remittance from the court of Spain for some unpaid invoices (including a benefit for his son Pomponio), and managed to transfer a well-remunerated state privilege onto his other son Orazio. The works of this period, which include some of Titian's best and most dramatic paintings, are often permeated by fear, sorrow, and anguish. The 180,000 inhabitants of Venice shared these feelings. Although the city's population was higher than ever before – indeed Venice would never be so populated again – its economy was facing a time of crisis, and the threat of Turkish invasion was becoming increasingly serious. A horrendous piece of news came from Cyprus, an important eastern offshoot of the Venetian Republic: on August 17, 1571, after a long siege, the fortress of Famagusta had fallen into Turkish hands. Commander Marcantonio Bragadin was flayed alive, and his skin, stuffed with hay, was displayed on the walls of the castle for everyone to see.

■ Titian, *Child with Dogs*, c.1570, Museum Boymans-van Beuningen, Rotterdam. A mysterious work of Titian's late years, this is often considered just a fragment of a larger composition. The figures in the foreground are threatened by a fire behind them. The rubbed, mellow brushstrokes are typical of the painter's final years.

■ Titian, *Christ Carrying the Cross*, c.1570, Hermitage, St Petersburg. The anxious look on Christ's face, the stained colors, and the vivid sense of the weight of the cross contribute to an atmosphere of anxiety and tension.

■ Titian, *The Crown of Thorns*, c.1572, Alte Pinakothek, Munich. Here, Titian returns to a theme he had explored thirty years ealier in a work now in the Louvre (see p. 74). This time, the scene is made even more bitter and tragic.

■ Titian, *Self-portrait*, 1567, Museo del Prado, Madrid. In this moving, intense representation of a soul, Titian portrayed himself as an old, lonely man, grown feeble and weak. His right hand, however, still has a firm grasp of the brushes, and his lively, sharp eyes seem gaze beyond time, toward eternity.

Tarquin and Lucretia

Executed in about 1572, this work is housed in the Museum für Angewandte Kunst in Vienna. Titian painted most of this superb masterpiece of anguish and violence with his fingers: he applied the color without smoothing it, neglecting outlines and deliberately leaving many details barely sketched.

■ Titian, *The Jealous Husband*, 1511–12, Scuola del Santo, Padua. The vicious stabbing of a helpless, innocent victim is a recurring theme in Titian's works. In this early Paduan fresco, the act of violence is portrayed as a brutal episode.

■ Titian, *Tarquin and Lucretia*, 1515, Kunsthistorisches Museum, Vienna. This version has a unique, almost sensual atmosphere, and can be included in the genre of voluptuous female half-figures. A totally different tone, one of tragedy this time, enveloped the criminal ambush and the stabbing in the lost *Death of St Peter Martyr* (1528–30, see p. 60).

■ Titian, *Tarquin and Lucretia*, detail, 1570, Musée des Beaux-Arts, Bordeaux. After the serious wounding of his son Orazio, stabbed in Milan in 1559, the dagger became a regular presence in Titian's late works, where it symbolized human cruelty. In about 1570, Titian painted the subject of Tarquin and Lucretia on two more occasions. These versions can be found in Vienna and Cambridge.

1570-1576

The Battle of Návpaktos

The ever more powerful and aggressive Ottoman empire expanded its belligerent presence in the Mediterranean: in 1570, Cyprus, an important Venetian colony, was attacked. Doge Alvise Mocenigo encouraged the formation of a league of Christian powers – consisting of the Pope, the Augsburgs of Austria, and Philip II of Spain – to oppose the advance of the Turks. In 1571, as horrible news arrived from Cyprus, the Venetian government introduced strict measures to support the enormous war effort of the Arsenal in view of a final battle. Out of the 380 vessels that constituted the Christian fleet, 210 belonged to the Venetian army, and were led by Commander Don John of Austria. The final battle took place in the waters of Návpaktos on October 7, 1571. It was a great victory for the Christian allies, and the triumph was greeted with celebrations, processions, and vows to the Virgin Mary. Titian became involved, but he had lost the enthusiasm of his younger years: the government requested a large painting for the Doges' Palace, but it was never executed, and Philip II had to make do with an old unfinished work that Titian had "recycled" (see p. 115). With the Ottoman threat gone, the league disbanded. Exhausted by war expenses, and by the fires at the Doges' Palace and at the refectory of San Zanipolo, Venice signed a peace agreement in 1573, leaving Cyprus to the Turks. The island had been given to the Republic by Queen Caterina Cornaro. The Venetian empire was on the verge of collapse.

■ The exotic costume of a Turkish ambassador in Venice, as portrayed in a 17th-century drawing.

■ With almost 3,000 workers, the Venetian shipyard of the Arsenal was the largest industry in Europe. The master carpenter (or head engineer) and the head accountant of the Arsenal were among the highest paid officials within the Venetian administration.

■ This 16th-century print represents the initial position of the ships of the Christian allies in the Battle of Návpaktos. A skilful manoeuvre by Venetian admiral Sebastiano Venier managed to break the Turkish fleet, and more than 150 Ottoman galleys were either sunk or captured.

■ Veronese, *Allegory of the Battle of Návpaktos*, 1571, Gallerie dell'Accademia, Venice. All the paintings celebrating the victory of Návpaktos hint at the barely averted tragedy. In this canvas by Veronese, many saints rush to the Virgin Mary to offer their help while, below them, the battle still rages.

■ This 16th-century sign for the union of the Arsenal carpenters shows the workers busying themselves in the shipyard.

The plague and the fire of Venice

In 1576, a deadly outbreak of the plague hit Venice: just under a quarter of the population was wiped out. Those who could, tried to flee to the islands in the lagoon or to the mainland, but many were prevented from landing by armed farmers fearing contagion. The studio at Biri Grande soon became empty. Titian's son Orazio remained, but eventually caught the plague, and was moved to the Lazaret, a quarantine station for victims of the disease, where he died a few months later. Abandoned by everybody, alone as he had never been in his life, Titian died on August 27, 1576, surrounded by his final masterpieces. In a surprising exception to its strict hygienic measures, the senate of Venice decided that Titian should not be buried in the communal grave, but in the Basilica dei Frari, as he had wished. However, Titian was to have a "second death": on December 20, 1577, the Doges' Palace was again destroyed by fire: the wing housing the Sala del Maggior Consiglio collapsed, and many works by Titian were burnt, including his official portraits of the doges.

■ Giovan Battista Tiepolo, *St Thecla Delivering the City from the Plague*, detail, 1757, Duomo di Este, Padua. The plague tormented Venice for several centuries, until the 1700s, but the outbreak of 1576 was the most devastating.

■ Mathias Grünewald, *The Isenheim Altarpiece*, detail, 1516, Musée d'Unterlinden, Colmar, France. The sores on the body of Christ are reminiscent of the tumors and pustules of the plague.

■ At the end of the plague, the senate of Venice asked Andrea Palladio to design a votive church on the banks of the nearby island of Giudecca. His church of Il Redentore strongly influenced the landscape of Venice.

■ Pieter Bruegel the Elder, *The Triumph of Death*, Museo del Prado, Madrid. The omen of a catastrophe sent a shiver across 16th-century Europe.

Bruegel's work, painted a few years before the plague of 1576, is still one of the strongest, most dramatic representations of the epidemic.

■ Ludovico Pozzoserrato, *The Fire at the Doges' Palace*, Museo Civico, Treviso. The fire that destroyed the Doges' Palace, just before Christmas 1577, was a recurrent theme in works by artists from the Veneto.

The heritage of a genius

Titian's death in the summer of 1576, at the height of the pestilence, had a profound effect on the development of art in the Veneto. Tintoretto was given the most important commissions in the city, like the Scuola di San Rocco, and, after the fire of 1577, the reconstruction and the new decorative work of the Doges' Palace. Virtually nothing remained of Titian's enormous wealth and assets: the house of Biri Grande, left empty, was looted. After Orazio's death in the Lazaret (October 20, 1576), Titian's only heir was his son Pomponio, who started to auction his father's works as early as 1581. Titian's heritage from a spiritual and artistic point of view, however, lasted much longer. Up until Impressionism in the 1900s, many artists were explicitly influenced by him. Among the most passionate admirers of his work were the protagonists of the artistic scene of the 17th century – such as Velázquez, Rubens, van Dyck, and Rembrandt – then Goya, Delacroix, and the Impressionists. An 18th-century writer from the Veneto commented of Titian's influence: "Unlike the Arabian Phoenix, he lives, and will live not only every 500 years, but throughout the centuries."

■ The 19th-century celebrations of Titian, such as this painting representing his funeral (Gallerie dell'Accademia, Venice), seem like a belated compensation toward the artist, who remained buried under a squalid tombstone at the Basilica dei Frari for almost 300 years.

■ Titian, *Pietà*, detail, 1576, Gallerie dell'Accademia, Venice. This altarpiece, intended for Titian's tomb, was never used for this purpose. In the lower right-hand corner is a minuscule painting-within-a-painting. It is a simple votive image representing him and his son Orazio kneeling in front of the Virgin Mary, pleading for their welfare during the plague. These were probably his last brushstrokes.

■ Created by several 19th-century sculptors, Titian's imposing funerary monument was unveiled in 1852 along the right aisle of the Basilica dei Frari. It was not possible to execute sculptor Antonio Canova's suggested model, which was instead used for his own tomb, erected directly opposite Titian's.

■ Antonio Canova, *Sketch for Titian's Monument*, Museo Correr, Venice. After the fall of Venice, in 1797, Canova thought of a great monument for Titian that would also keep alive the memory of the the Republic's past magnificence. The sepulchre, painstakingly designed in sketches and wooden and terracotta models, simulated the entrance to a pyramid. Canova adapted the idea for the Viennese mausoleum of Maria Christina of Austria.

■ El Greco, *Allegory of the Holy League*, detail, Monastery of St Lawrence, Escorial. Frightened by the deadly plague, El Greco fled to Spain, where Philip II offered him a position as court painter. El Greco's first Spanish works reflect his years in Venice, especially in his use of color. They are also characterized by a twisted imagination that was later to become hallucinatory.

129

1570-1576

Pietà

Housed in the Gallerie dell'Accademia in Venice, this is Titian's last work. It was started in 1570 and some details were left unfinished at the time of his death, in 1576. Intended for his tomb but never used for this purpose, it was completed by Jacopo Palma il Giovane, as indicated by the inscription at the bottom.

■ Along the slopes of the huge cornice framing the composition are some feeble, gloomy lamps shedding a smoky light on the scene. At either side of the painting are statues of Moses and the Sibyl of the Hellespont.

■ The apse is decorated with a mosaic portraying a religious symbol – a pelican tearing her chest open to feed her chicks. It is an allusion to the death of Christ, but also to the loving rapport between Titian and his son Orazio, who died of the plague.

■ In the touching figure of Nicodemus, Titian created his last – and most moving – self-portrait. Approaching his nineties, the artist kneels in front of the dead Christ almost completely undressed. He even removed the traditional skull cap that concealed his baldness in all of his other late self-portraits.

■ Titian, *Diana and Callisto*, 1556–59, National Gallery of Scotland, Edinburgh.

Note

The places listed in this section refer to the current location of Titian's works. Where more than one work is housed in the same **place***, they are listed in chronological order.*

■ Titian, *Crucifixion*, 1558, Chiesa di San Domenico, Ancona.

■ *Perspective drawing of the city of Ferrara in 1490*, Biblioteca Estense, Modena.

■ Loggia di Davide,
Palazzo del Tè, Mantua.

■ Palazzo Pitti,
site of the Galleria
Palatina, Florence.

■ Titian, *St John the Baptist*, 1540, Gallerie dell'Accademia, Venice.

■ Palazzo Ducale, Urbino.

Note

■ *Portrait of Ludovico Ariosto*, from an edition of *Orlando Furioso*, Venice, 1536.

■ Jacopo Bassano, *Country Scene*, Thyssen Collection, Lugano.

■ Giorgione, *Self-portrait*, c.1508, Herzog Anton Ulrich-Museum, Braunschweig.

■ Leonardo, *Isabella d'Este*, 1500, Musée du Louvre, Paris.

statues for the Emperor's family, pp. 92, 100.

Lotto, Lorenzo (Venice, c.1480 – Loreto, 1556), painter who led a nomadic existence, little respected by Titian and Aretino, he left mostly religious paintings in several Italian towns, pp. 54, 74, 88.

Madruzzo, Cristoforo, bishop of Trent during the XIX Ecumenical Council that started in 1542, p. 83.

Manuzio, Aldo the Elder (Bassiano, 1450 – Venice, 1516), founder of a family of Venetian engravers, he invented the Aldine typeface, p. 30.

Maximilian I of Augsburg (1458–1519), emperor from 1508, he fought in Italy against France and Venice as part of the Holy League. He agreed to the Treaty of Cambrai, pp. 16, 17.

Michelangelo (Buonarroti) (Caprese, Arezzo, 1475 – Rome,

1564), sculptor, painter, architect, and poet, active in Florence and Rome, where he left such masterpieces as the *Pietà* and *The Last Judgment*, a fresco in the Sistine Chapel in the Vatican, pp. 54, 64, 74, 78, 88, 113.

Moretto, real name Alessandro Buonvicino (Brescia, 1498 – c.1554), painter of the so-called "Lombard school", along with Savoldo and Romanino, pp. 44, 112.

Moroni, Giovanni Battista (Albino, Bergamo, c.1529 – Bergamo, 1578), painter who worked mostly in and around Bergamo, producing both religious paintings and portraits, p. 88.

Navagero, Andrea (Venice, 1483 – Blois, 1529), Venetian intellectual from a noble family, he was a poet, orator, commentator of Latin classics, and official historian of the Republic of Venice. He supported Titian in the latter's attainment of supremacy in Venice, p. 22.

Palladio, Andrea (Padua, 1508 – Maser, 1580), architect. He was largely responsible for the architectural profile that developed in Venice in the second half of the 16th century, pp. 94, 127.

Palma il Giovane, real name Jacopo Negretti (Venice, 1544 – 1628), painter, great-grandson of Palma il Vecchio, he worked in Titian's studio in about 1570, p. 130.

Palma il Vecchio, real name Jacopo Negretti (Serina, Bergamo, c.1480 – Venice, 1528), painter of the Venetian school, p. 60.

■ El Greco, *The Burial of Count Orgaz*, detail, 1586, Church of Santo Tomé, Toledo.

■ Albrecht Dürer, *The Emperor Maximilian I*, 1517, Kunsthistorisches Museum, Vienna.

■ Paolo Veronese,
The Feast in the House of Levi, 1573, Gallerie dell'Accademia, Venice.

Vecellio, Lavinia (Venice, 1530 – Serravalle di Vittorio Veneto), the beloved third-born of Titian and Cecilia Soldano, in 1555 she married Cornelio Sarcinelli, a gentleman from Vittorio Veneto, pp. 50, 96.

Vecellio, Orazio (Venice, 1525–76), the second child of Titian and Cecilia Soldano, he stayed with his father throughout his life, helping him in the studio of Biri Grande as well as in the administration of their wealth. He died of the plague a few months before Titian's own death, pp. 50, 51, 78, 100, 120, 123, 126, 128, 131.

Vecellio, Pomponio (Venice, born 1520), the first-born of Titian and Cecilia Soldano, he left the paternal home to pursue an ecclesiastical career, pp. 50, 120, 128.

Venier, Francesco, doge from 1554 until his death in 1556, he commissioned several works of art from Titian, p. 95.

Veronese, real name Paolo Caliari (Verona, 1528 – Venice, 1588), painter, worked closely with Palladio, whose Villa Maser he decorated. He also created paintings for the Library of St Mark and the Doges' Palace, pp. 89, 112, 125.

Zuccato, family of painters and mosaic-makers originally from the Valtellina region, working in Venice in the 16th and 17th centuries, p. 8.

■ Palma il Giovane,
Self-portrait, c.1580, Pinacoteca di Brera, Milan.

A DK PUBLISHING BOOK
Visit us on the World Wide Web at http://www:dk.com

TRANSLATOR
Sylvia Tombesi-Walton

DESIGN ASSISTANCE
Joanne Mitchell

MANAGING EDITOR
Anna Kruger

Series of monographs
edited by Stefano Peccatori and Stefano Zuffi

Text by Stefano Zuffi

PICTURE SOURCES
Archivio Electa
Archivio Mondadori
Elemond Editori Associati wishes to thank all those museums and
photographic libraries who have kindly supplied pictures, and would be pleased
to hear from copyright holders in the event of uncredited picture sources.

Project created in conjunction with
La Biblioteca editrice s.r.l., Milan

First published in the United States in 1999 by DK Publishing Inc.
95 Madison Avenue, New York, New York 10016

ISBN 0-7894-4141-1

Library of Congress Catalog Card Number: 98-86758

First published in Great Britain in 1999
by Dorling Kindersley Limited,
9 Henrietta Street, London WC2E 8PS

A CIP catalogue record of this book is available from the British Library.

ISBN 0751307238

2 4 6 8 10 9 7 5 3 1

Printed by Elemond s.p.a. at Martellago (Venice)